THE PRE-RAPHAELITES

INSPIRATION FROM THE PAST

TERRI HARDIN

TODTRI

This book was designed and produced by
TODTRI Book Publishers
P.O. Box 572, New York, NY 10116-0572
FAX: (212) 695-6984
e-mail: info@todtri.com

Printed and bound in Singapore

ISBN 1-880908-76-X

Visit us on the web!
www.todtri.com

Author: Terri Hardin

Publisher: Robert M. Tod
Book Designer: Mark Weinberg
Production Coordinator: Heather Weigel
Senior Editor: Edward Douglas
Project Editor: Cynthia Sternau
Assistant Editor: Don Kennison
Desktop Associate: Michael Walther
Typesetting: Command-O, NYC

Picture Credits

Agnew & Sons, London—Bridgeman/Art Resource, New York 116

Birmingham City Museums—Bridgeman/Art Resource, New York 14-15, 56-57, 69

Bradford Art Galleries and Museums—Bridgeman/Art Resource, New York 22, 36, 127

Christie's, London—Bridgeman/Art Resource, New York 125

De Morgan Foundation, London—Bridgeman/Art Resource, New York 118

Detroit Institute of Art, Detroit, Michigan 106

Falmouth Art Gallery, Cornwall—Bridgeman/Art Resource, New York, 109

Fitzwilliam Museum, Cambridge—Bridgeman/Art Resource, New York 65

Forbes Magazine Collection, London—Bridgeman/Art Resource, New York 68

Forbes Magazine Collection, New York—Art Resource, New York 98, 122

Faringdon Collection, Fardingdon—Bridgeman/Art Resource, New York, 95, 112-113

Gulbenkian Museum, Lisbon—Art Resource, New York 88-89

Johannesburg Art Gallery—Bridgeman/Art Resource, New York 30

Keeble College, Oxford—Bridgeman/Art Resource, New York 50

Lady Lever Art Gallery, Port Sunlight/Art Resource, New York 48-49, 72-73, 74, 77

The Louvre, Paris—Art Resource, New York 13

Manchester City Art Galleries—Bridgeman/Art Resource, New York 44, 46, 58, 63, 66, 108, 111

Musée d'Orsay, Paris—Art Resource, New York 117

Museo de Arte, Ponce, Puerto Rico—Bridgeman/Art Resource, New York 61

National Gallery, London—Bridgeman/Art Resource, New York 81

National Trust, London—Art Resource, New York 4

Palacio Medici Riccardi, Florence—Art Resource, New York 16

The Pierpont Morgan Library—Art Resource, New York 5

Private Collection—Bridgeman/Art Resource, New York 11, 101, 103, 110, 114

San Gimignano, S. Agostina and Collegiata—Art Resource, New York 26

The Tate Gallery, London—Bridgeman/Art Resource, New York 7, 10, 18, 21, 27, 31, 33, 34-35, 38, 39, 40-41, 42, 43, 45, 47, 51, 52-53, 54-55, 59, 60, 62, 64, 70, 78, 79, 80, 82, 83, 84, 85, 86, 87, 89, 94, 96, 99, 102, 104-105, 115, 119, 120-121, 123, 124

The Vatican, Rome—Art Resource, New York 24-25

Uffizi, Florence—Art Resource, New York 32

Usher Gallery, London—Bridgeman/Art Resource, New York 67

Victoria & Albert Museum, London—Art Resource, New York 12, 17, 19, 23, 75, 76, 90, 91, 92-93, 93, 97, 107, 126

Victoria & Albert Museum, London—Bridgeman/Art Resource, New York 8-9

Walker Art Gallery, Liverpool—Bridgeman/Art Resource, New York 6, 28-29, 37

William Morris Gallery—Bridgeman/Art Resource, New York 100

759.2
H

CONTENTS

INTRODUCTION

The modern eye, which is perhaps accustomed to examining (if not actually interpreting) contemporary art in an abstract way, may too frequently define the paintings of the Pre-Raphaelite Movement (1848–1910) as somewhat quaint and extravagant. Yet the earliest pictures of the movement drew their inspiration from literary sources—notably John Keats and William Blake, in addition to William Shakespeare and biblical themes—much admired by the painters. And their painterly style, marked by bright color and intense emotion, inspired distinct praise and, often, devotion.

Thus it seems strange that many Victorian-era viewers of their work should have found, at least at first acquaintance, Pre-Raphaelitism enigmatic and unapproachable. It is now difficult to understand how scenes of ethereal damsels and heroic fellows, depicted in natural settings and at times with religious symbolism, could have sparked any kind of controversy, let alone a furor so intense that the greatest critic-philosopher of the nineteenth century, John Ruskin, would be obliged to step in and mediate. As old-fashioned as it may appear to us today, the Pre-Raphaelite art movement challenged its audience to revisit their expectations of art and design.

Antecedents

What is the nature of an art movement and where does it begin? The Pre-Raphaelite movement had the nature of a revolution; its beginnings date from 1848, a year that is notorious for unrest. In the decades following Napoleon's defeat, the countries of Europe had been attempting to redraw themselves into nationalistic enclaves. In 1848, those revolutions that had been long simmering suddenly erupted across the continent. In France, Austria, and Hungary; in Italy, Germany, and Czechoslovakia, nationalism vied with economic concerns as citizens turned upon their governments and upon one another.

As it was being practiced on the continent, revolution did not make its way to England, yet another, a more far-reaching reformist disruption was already present and was, in fact, changing the English way of life forever. Since the

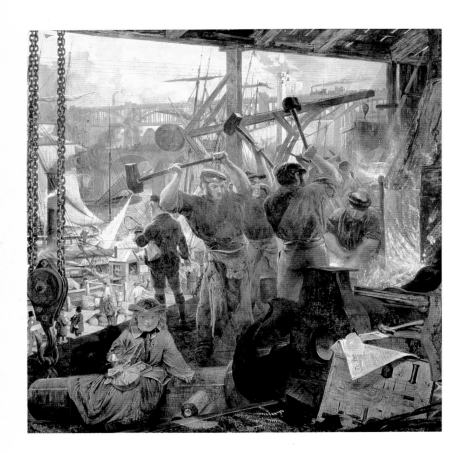

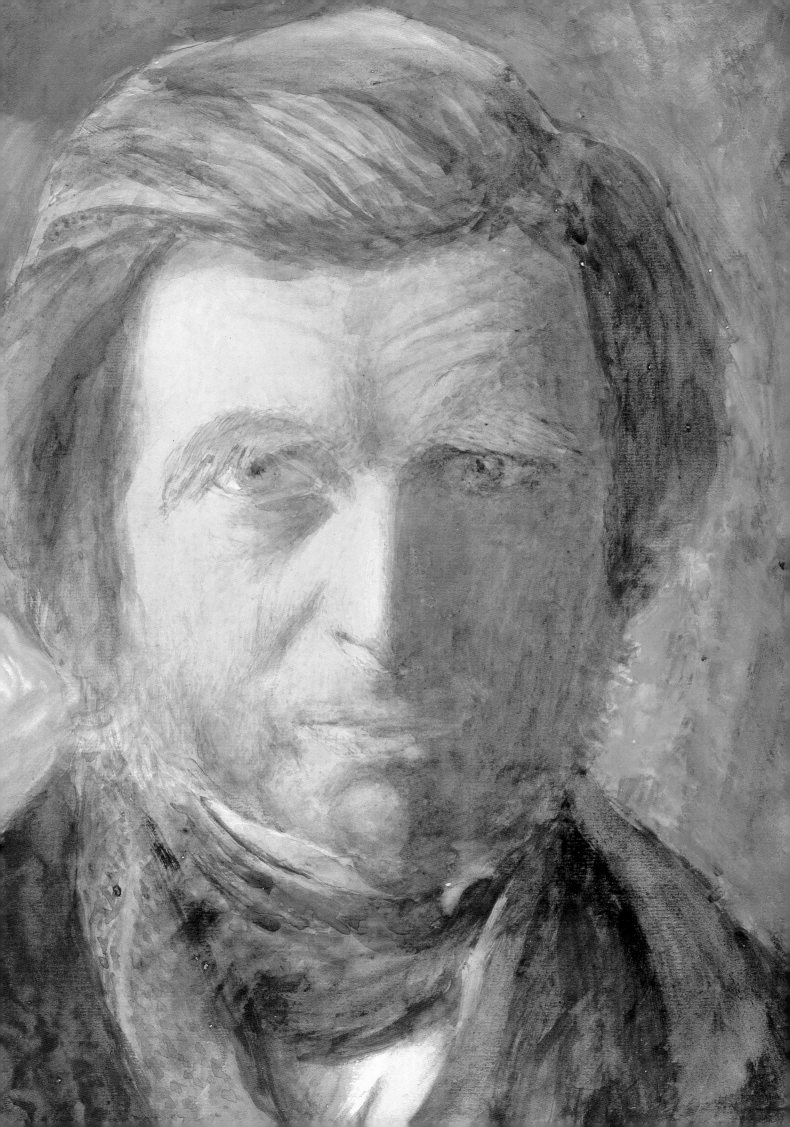

mid-to late-eighteenth century, Britain had been in the throes of what came to be called the Industrial Revolution, the social impact of which had, on the down side, introduced a new level of despair and squalor for urban lower classes and on the upside, promoted a new, more prosperous middle class. Thus as England's poor toiled in factories, middle-class families grew in wealth and prominence on their way to becoming the mainstay of the society.

It was a very small society: practically everyone knew one another, married one another, and came together in the pursuit of amusement and culture, which included appreciation of the arts. This new society supported art though invariably, and not surprisingly, on its own terms. For the most part, it wished art to mirror its newfound prosperity and elegance; to reflect the sleek new image presented by its bourgeoisie. Thus, the demand for portraits, miniatures, and other formal sittings rose considerably, and those artists who lived by flattery thrived. This was one of several reasons for the complacency felt at London's Royal Academy of Arts, where the founders of the Pre-Raphaelite movement— the Brothers, as they called themselves—had met and studied.

It seemed to some, particularly the early Brotherhood, that the early Victorians took a kind of perverse pride in their revolution—with its hellish factories blighting the cluttered landscape—because they wished to view their paintings, old and new, through a film of brown grime. It was the fashion of the day to overlay colorful pigments (which had perhaps stayed bright for centuries) with brown washes, rendering them drab, as if their owners wished to know nothing of a world that existed before coal-smoke.

Lorenzo and Isabella (Isabella)

detail; Sir John Everett Millais, 1849;
oil on canvas. Walker Art Gallery, Liverpool.
In this very early Pre-Raphaelite painting, the first appearance of "PRB," the sign of the Pre-Raphaelite Brotherhood, may be seen in the carving on the chair.

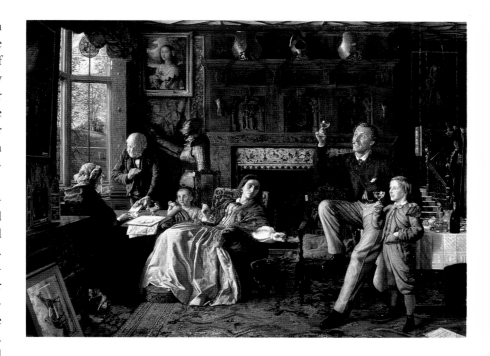

The Romantics and the Oxford Movement

Even within this insular, pragmatic society there were some changes in the wind. The most significant, certainly with regard to the burgeoning Pre-Raphaelites, was the romantic movement, which had begun with the French Revolution. In England, it was represented by the poets William Wordsworth and William Blake as well as Percy Bysshe Shelley, Lord Byron, and Keats. These in turn influenced Alfred Tennyson and Robert Browning, who were slightly older contemporaries of the Pre-Raphaelites.

The Pre-Raphaelites would glean much of their painterly inspiration from these literary sources. As artists inspired by the romantics, they turned their eyes away from the smokestacks on the horizon. They had great interest in medieval history and legend, as popularized by Sir Walter Scott, and in the tales surrounding King Arthur and the Knights of the Round Table. In addition, the works of Chaucer and Shakespeare were held in high regard. These essentially made up the lifeblood of the Pre-Raphaelites and their new style. As William

The Last Day in the Old Home

Robert Braithwaite Martineau, 1862; oil on canvas; 41 1/2 x 56 1/2 in. (105.4 x 143.5 cm). The Tate Gallery, London.
Although Martineau had shared a studio with Holman Hunt, this portrayal of a feckless rake who has brought ruin on his family is typical of the narrative, moralizing style that preceded the Movement.

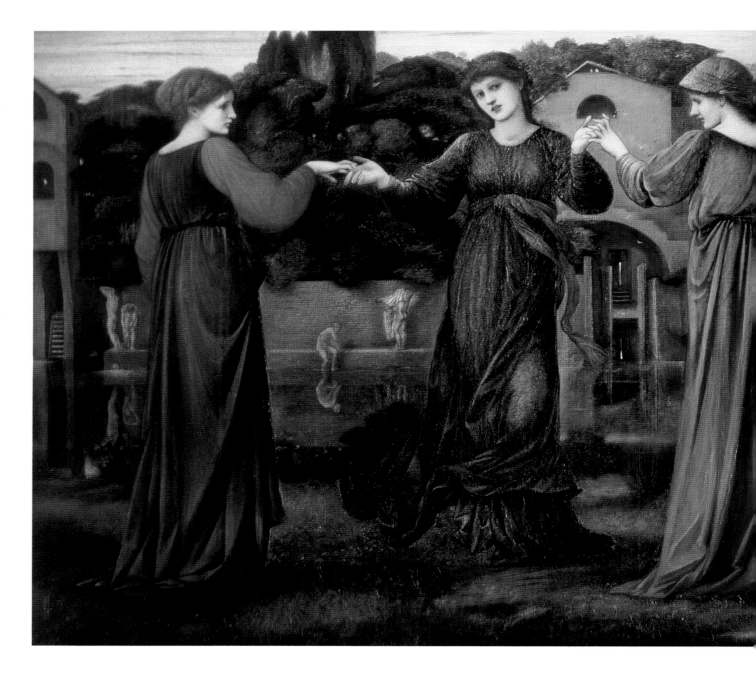

Morris would exhort readers of a later age in his *Earthly Paradise*, the object was to:

> Forget six counties overhung with smoke,
> Forget the snorting steam and piston stroke,
> Forget the spreading of the hideous town . . .
> (1869)

Of particular interest was the figure of Guinevere. Perhaps it was the stolid manner of Queen Victoria which made men yearn for the simple virtue of Arthur's queen. To the Pre-Raphaelites, Guinevere's fall from grace signified the precedence of passion over propriety—a very revolutionary thought at the time, and one that would appeal to artistic young men.

There was yet another revolution of sorts taking place in England—a small one, it did not affect everyone; yet it was powerful to those whom it reached. This was the Oxford movement (1833–1889), a spiritual movement ema-

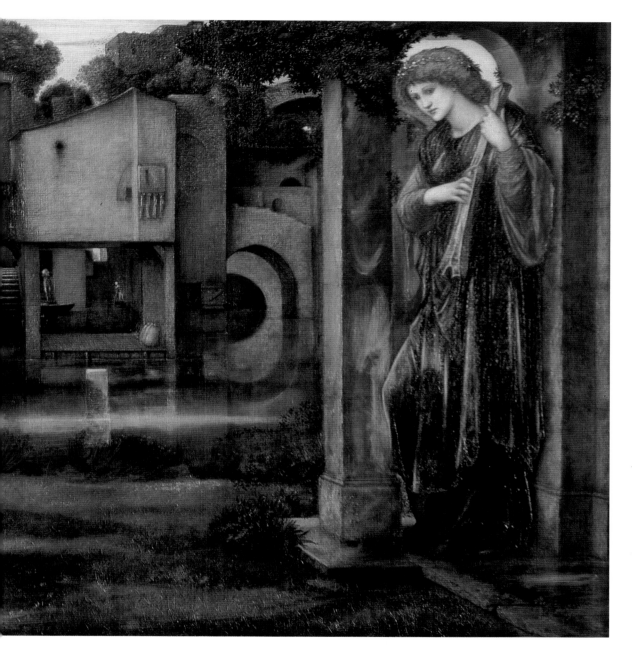

The Mill

Sir Edward Coley Burne-Jones, 1870–82; oil on canvas; 35 3/4 x 77 3/4 in. (90.8 x 197.5 cm). Victoria & Albert Museum, London. This is among Burne-Jones' most famous paintings. It was executed at the time that his success was realized, and he was able to paint it at his leisure.

nating from academic clerics who found themselves suddenly questioning the foundation of English Protestantism. The Oxford movement preached for a church separate from the state, a church where belief entailed a mystical experience, not merely a social convention. Its advocates, who became known as Tractarians, were judged to be very dangerous, for several of its most prominent members had converted to Roman Catholicism. The movement would bring about a crisis of faith for at least two Pre-Raphaelite followers.

Into this milieu of romance and religion, and in response to what they felt to be the ugliness of pragmatism, the young artists of the Pre-Raphaelite Brotherhood (at first, known only as P.R.B.), sought to bring about meaningful change. Perhaps they truly felt the status quo was stifling; that British art had been too long complacent; that the time had come for a revolution in the arts. Perhaps they were, in the beginning, just young men who believed that any change they could effect would be for the better.

Under One Roof

Dante Gabriel Rossetti (1828–1882) is the Brother most closely associated with Pre-Raphaelitism. Of the three principals, Rossetti was considered to have had the weakest grasp of the principles he espoused; and he was the first to diverge from the path. So how did he end up symbolizing the movement? Partly through cunning, and partly through luck and playing the hand that was dealt him. For unlike John Everett Millais (1829–1896) and William Holman Hunt (1827–1910), who proved in the long run to be staid Englishmen to their core, Rossetti was a romantic rebel who had nothing to lose in upsetting the social applecart. As the son of an Italian émigré, he felt he had no place in English society, and thus had no stake in it.

Furthermore, it was in the Rossetti household that three of the influences for social change were

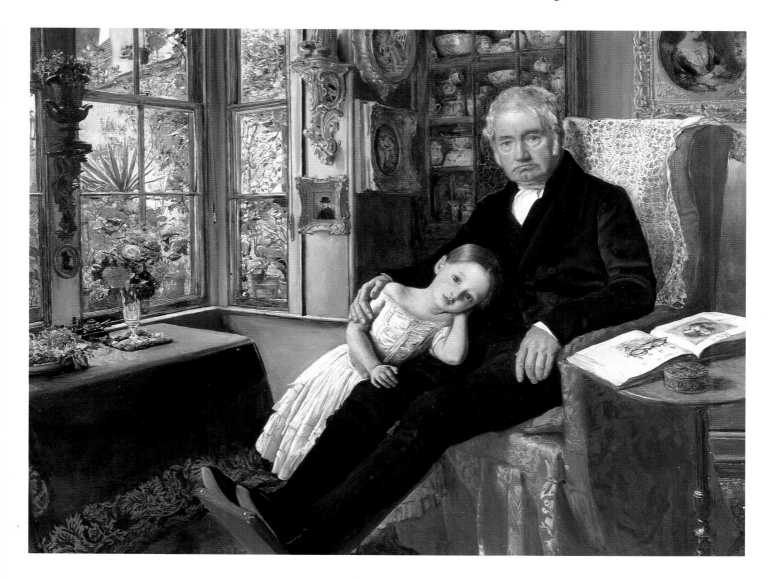

The Girlhood of Mary Virgin
detail; Dante Gabriel Rossetti, 1848;
oil on canvas. The Tate Gallery, London.
As an *homage* to the early Italian masters, perhaps Gozzoli himself, Rossetti has included a vinekeeper in the background. He is trimming his vines—a mundane counterpoint to the sacred scene in the foreground.

James Wyatt and His Granddaughter
Sir John Everett Millais, 1849; oil on canvas. Private collection.
Early on, Millais had gained the confidence of the wealthy middle class, who believed him to be "their kind of painter," despite his ties to Pre-Raphaelitism.

present and dominant. Revolution, romanticism, and religious fervor—all were to be found under the roof of Rossetti's parents. His father was Gabriele Rossetti, a poet and Neapolitan revolutionary who lived in exile, hoping to return eventually to his native Italy. His mother was profoundly religious and influenced by the turmoil within the Anglican church (as was Rossetti's sister, Christina). These influences found their synthesis in the young Rossetti.

Although Pre-Raphaelitism originated as a purely artistic aesthetic, among the first to sympathize with the fledgling movement were those interested in social reform (with the exception of, at first, Charles Dickens). The idea of Pre-Raphaelitism having social relevance probably began with Rossetti's teacher, Ford Madox Brown, and his opinions on Christian socialism. This mutated briefly into Christian Idealism, a mystical connection espoused by Pre-Raphaelite sympathizer William Cave Thomas. Artists such as Holman Hunt painted pictures of religious and moral significance, and yet, social significance was not part of the mainstream of the movement—certainly not in the later paintings of Millais and Rossetti—until some years following.

Pre-Raphaelitism, like romanticism, was essentially an escapist movement. In wishing to go back to a world prior to the High Renaissance of Italian master painter Raphael, the Pre-Raphaelites were

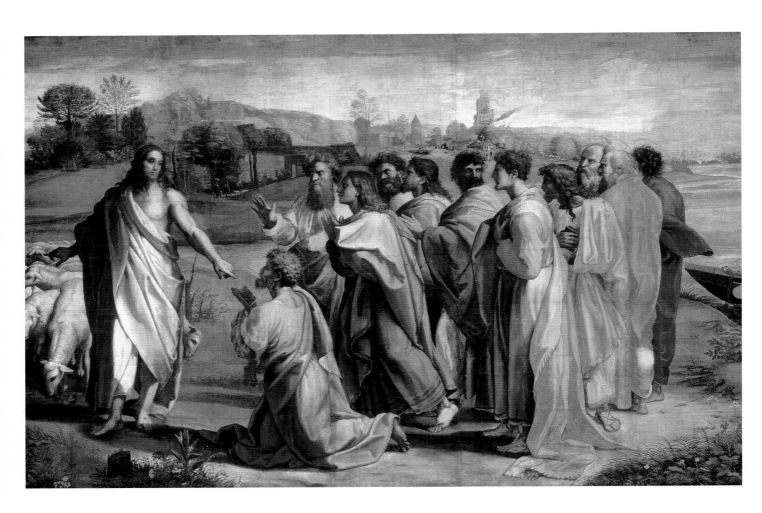

Cartoon for Tapestry, *Christ's Charge to St. Peter*
Raphael, 1515-16; oil on paper; 135 3/4 x 209 3/4 in.
(3.41 x 5.32 m). Victoria & Albert Museum, London.
The Pre-Raphaelites did not appear to appreciate the Renaissance motto "Man is the measure of all things," preferring to set their human subjects in a world teeming with all forms of life.

Count Baldassare Castiglione
Raphael, 1514; oil on canvas;
32 1/4 x 26 3/8 in. (82 x 67 cm). Louvre, Paris.
Despite the contempt in which the Pre-Raphaelites held him, Raphael was, and continues to be, one of the masters of Western art, as demonstrated by this warm, quiet portrait.

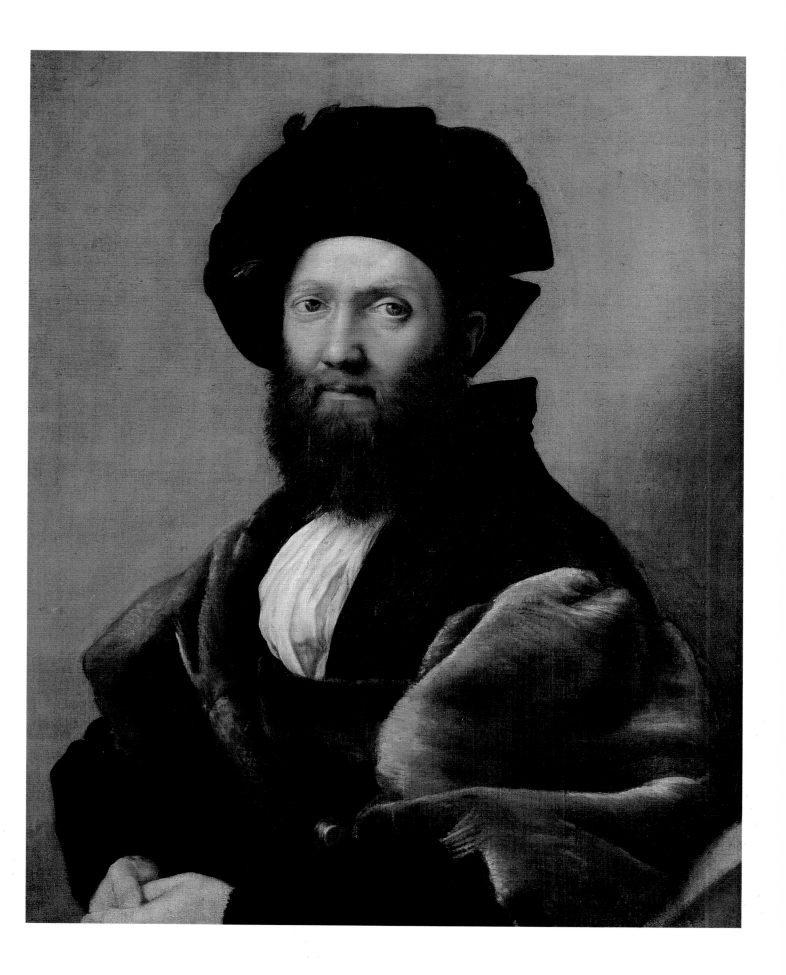

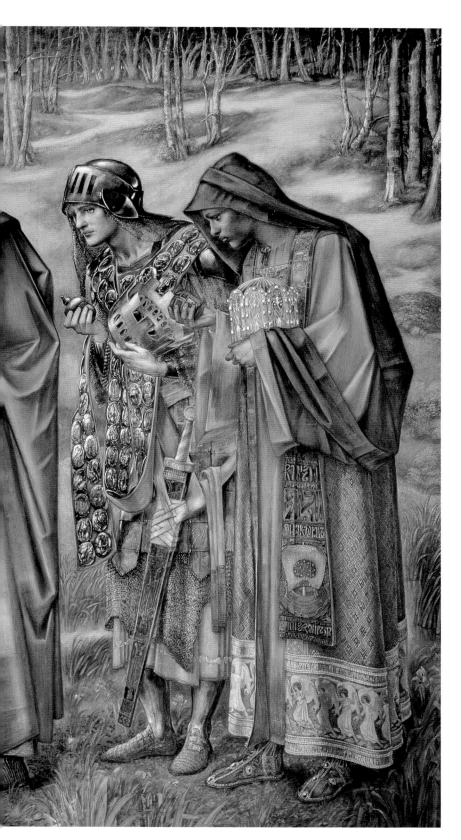

also attempting to return to a pre-Industrial era, a pastoral society where products were made by hand, and the skies undiluted with coal smoke. They took as their utopia the imaginary middle ages of Thomas Malory's *Morte d'Arthur*, which saw the rise of the guilds (i.e., the age's middle class). This revivalism (or revisionism) had created a new appreciation of Shakespeare and Chaucer, a nostalgia for things past in the midst of the Industrial Revolution's great yet intimidating technological innovations.

The Measure of Success

How else can one measure the success of the Pre-Raphaelite movement? For one thing, we know that it was a success simply because the term "Pre-Raphaelite" lost its specific meaning, and came to mean "anything good." This was practiced even by aesthetes as precise as Ruskin, who once went so far in his enthusiasm as to refer to Turner as a sort of "pre-Pre-Raphaelite."

The new aesthetic was also very inspiring to other artists. William Morris (1834–1896), simultaneously a dreamer and a pragmatist, was later considered a Pre-Raphaelite. He was able to recreate a romantic medieval milieu and recall it through his Arts and Crafts movement. His unique design system evolved then into Art Nouveau, laying the groundwork for a renaissance in crafts and book illustration and inspiring, among others, such artist-illustrators as Aubrey Beardsley, Walter Crane, and Arthur Rackham. And certainly the paintings of Edward Burne-Jones (1833–1898) must be considered Pre-Raphaelite, taking on as they did the subject matter and symbolism that were principles of the movement.

Art movements are living things. As the principals Millais and Rossetti diverged from the Pre-Raphaelite ideal, so that ideal changed; others, however, would take up the charge. As with all art, we can only use our eyes and hearts to judge whether the effort was worthwhile.

The Star of Bethlehem

Sir Edward Coley Burne-Jones, 1888-91; oil on canvas; 101 x 152 in. (232.5 x 386 cm). Birmingham City Museums, Birmingham. Burne-Jones' Magi are magnificent, but the world surrounding them is less vivid, and far less important. Man is again the measure of all things.

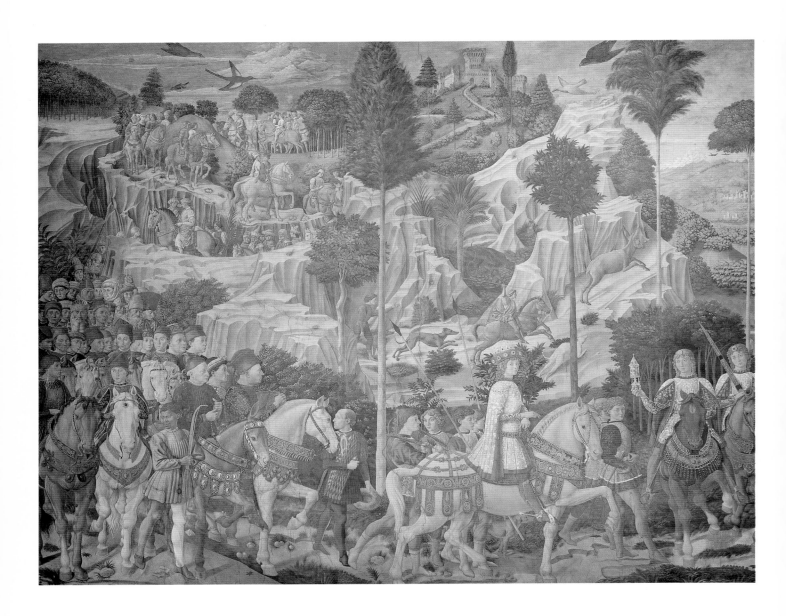

Procession of the Magi

Benozzo (di Lese) Gozzoli, 1459;
fresco. Palacio Medici Riccardi, Florence.
This fresco, one of Gozzoli's most famous,
demonstrates the qualities honored by the
Pre-Raphaelites—realism of detail, coupled
with a use of bright, naturalistic color.

Artichoke Wallpaper

William Morris, 1899; print. Victoria & Albert Museum, London.
One result of the Pre-Raphaelite movement was the increased
appreciation of the natural element of design. This print
verges on the modern use of geometric, repetitive decoration.

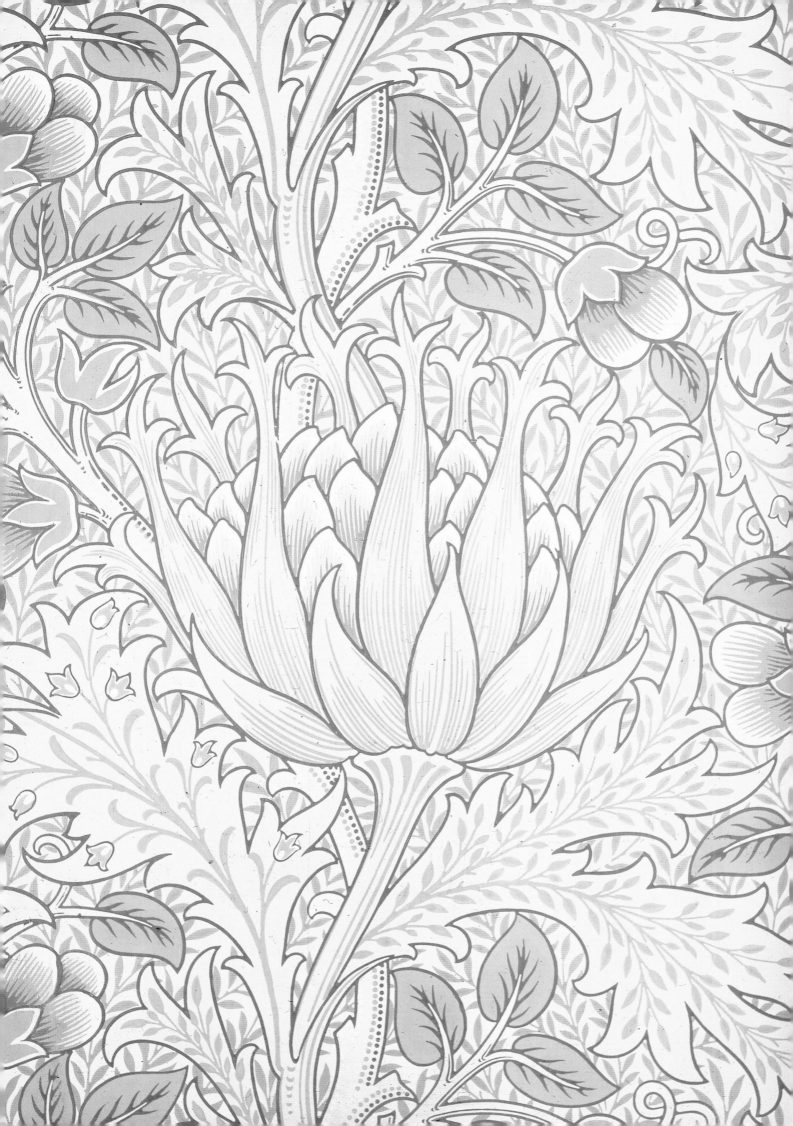

F. G. Stephens

William Holman Hunt, 1847; oil on wood; 51 1/2 x 44 1/2 in. (20.3 x 17.5 cm). The Tate Gallery, London.
Stephens became one of the seven Brothers at Holman Hunt's suggestion. Like William Michael Rossetti,
he experienced his greatest success as a critic. He also had the unenviable task of keeping tabs
on Annie Miller while Holman Hunt roamed the world.

1848-1851: THE FOUNDING OF THE BROTHERHOOD

The Pre-Raphaelite Brotherhood was founded in September of 1848 by William Holman Hunt, John Everett Millais, and Dante Gabriel Rossetti, within a year of their meeting.

The idea of a brotherhood itself was not uncommon. Many such brotherhoods had been formed at Oxford before and after this time; the Apostles being one of the most famous (whose members included Browning and Tennyson) and, later, the "Brotherhood," among whom Morris and Burne-Jones counted themselves.

Of the founding brothers, Holman Hunt and Millais were closest. The son of a well-to-do family from the isle of Jersey, Millais had entered the Royal Academy Schools in 1840. At the age of eleven, a sketch called *A Scene from "Peveril of the Peak"* (1841) would show the promise which led to his becoming one of the most accomplished artists of his day. It was about this time that Holman Hunt had first heard of Millais:

> My sister told me that some friends of hers at Holloway had a young nephew who was a perfect wonder in his power of drawing; he was only about twelve, was already a student at the Royal Academy and four years before had won at the Society of Arts. His name was Millais. The boy came to his uncle's house and made drawings which all agreed were marvellous. What surprised me more than anything else in this statement was that the boy's family were delighted at the prospect of his becoming an artist.

To Holman Hunt, this was especially poignant. He himself hungered for the unconditional parental encouragement showered on Millais (and later, he would find, on Rossetti). He was the son of a warehouse manager, and although his parents had sympathy for his artistic longings, they felt that a "proper job" would better

suit him and pressured him to serve as an apprentice. It was through his setting aside part of his salary for painting lessons and his perseverance that he finally did convince them of his sincerity. They were still, however, of two minds about his ambition, particularly when he was at first turned down by the Academy in 1847.

Although Holman Hunt was later accepted, he claimed that this setback helped him to achieve the proper outlook: "I had gained much by my humiliation before being accepted as a student, the principal good lying in the discovery that an artist must himself ever sit in judgment upon his art, and throw away the 'worser part.'" Holman Hunt continued his lessons while combing the National Gallery, studying its pictures. From these he "gained a practical knowledge of the Ancient Masters then represented in London; and this was fast becoming of importance in my eyes, helping me for my own guidance to look more independently upon the state of art as developed by living men."

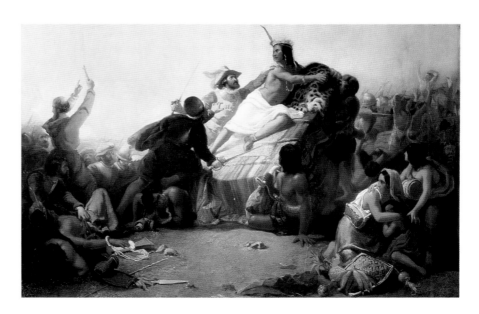

Pizarro Seizing the Inca of Peru

Sir John Everett Millais, 1845; oil on canvas. Victoria & Albert Museum, London.

Millais was reckoned a prodigy; and was encouraged from an early age to pursue painting as a career. Parental support of such a calling astounded his friend, William Holman Hunt.

The Rossettis

Dante Gabriel Rossetti's background, among those of the three founding Brothers, was certainly the most romantic. Since birth, Rossetti had been part of an artistic household. Dante's father, Gabriele Rossetti, was a poet of some celebrity who had been forced to leave his native Naples for siding with Garibaldi against the monarchy. Gabriele was welcomed in England by those familiar with his writings, and the Rossetti home became a salon where some of the earliest Pre-Raphaelite sympathizers congregated. Rossetti's mother's family, the Polidoris, were also artisticly inclined—in fact, Dante's maternal uncle John had been Lord Byron's physician. The Rossetti clan included a younger brother William Michael (1829–1919), who would join the Brotherhood, becoming its chronicler, and a sister, Christina (1830–1894), whose name would also be associated with the Pre-Raphaelite Movement and who would become a famous poet in her own right.

In spite of the abundance of talent to be found within this household, the Rossetti family was close to poverty. In addition, several of them—beginning with mother Frances and including Dante and Christina—were affected by a natural inclination to melancholia that blighted and gradually assumed control of their lives. For this reason (as well as the anxiety bred of poverty), setbacks of both a professional and private nature cast a greater pall in their psyches than they would perhaps have had in others, with dramatic consequences.

Rossetti had been considered a wunderkind. To the delight of his parents (particularly his father), his flame fanned out in all directions. He was precocious, drawing with absorption at four, writing a play at five, translating the poetry of his namesake Dante at seventeen. Dante turned out to be a lasting interest for the painter; until the end of his life, he was obsessed with the poet, translating and rendering scenes from his life and works.

Like many of his time, Rossetti read with interest the romances of Sir Walter Scott and the poetry of the romantics. He was enamored of medievalism and legends of chivalry. It was considered a failing of Rossetti's that he was unable to draw his subjects in contemporary dress; one might say that, in a very real way, Rossetti's creative energies were bound up in the *quattrocentro*. As an important artist and poet, he would excite the public's taste for these subjects.

Rossetti was studying at the Royal Academy in 1848, although, like Holman Hunt, he had at first been turned down. It was said that, as a painter, Rossetti perhaps lacked the discipline to conquer classical forms; yet this failure may have coerced the Pre-Raphaelites into searching for artistic alternatives, harking back to the pre-Renaissance when proportion and perspective—concepts that Rossetti could never master—were more an option than a necessity. Rossetti was originally taught drawing by John Sell Cotman, who was Professor of Drawing at King's College in 1834. Cotman, who himself had no formal artistic training, was an excellent draftsman of architectural subjects. Among his many accomplishments was the book *Etchings Illustrative of the Architectural Antiquities of Norfolk*, published in 1818. Presumably, such a man would have been able to teach Rossetti perspective, if no one else could.

The actual inspiration of the Pre-Raphaelites—for which name Ruskin was later to say, "I cannot compliment them on common sense"—came in fact from a number of sources. First and foremost, Pre-Raphaelitism stemmed from romanticist tendencies (later to be called the Gothic movement). Literary inspiration was drawn primarily by the romantic poets and authors who had written of a legendary past, inhabited by brave men and beautiful women, such as Chaucer and Shakespeare.

One enthusiast was the painter Ford Madox Brown (1821–1893). Born in Calais, Brown was educated on the continent, and grew to appreciate a form of romantic painting referred to as the German Nazarene school, whose eighteenth-century practitioners included Friedrich Overbeck, Peter von Cornelius, and its master, Casper David Friedrich. Brown had read of Chaucer in Sir James Mackintosh's *History of England*, and this began a lifelong appreciation. Madox Brown's picture, *The First Translation of the Bible into English: Wycliffe Reading his*

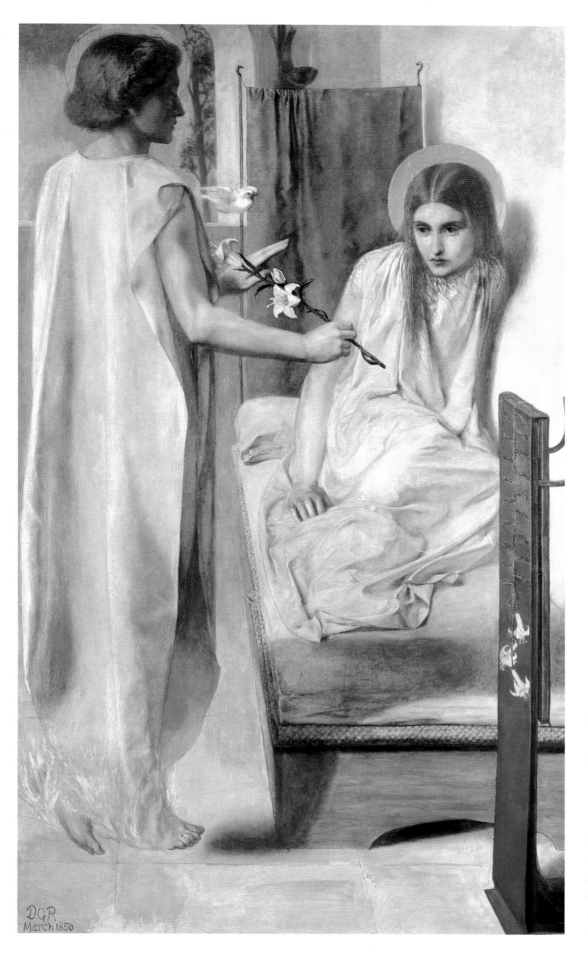

Ecce Ancilla Domini (The Annunciation)
Dante Gabriel Rossetti, 1849–50; oil on canvas; 28 1/2 x 16 1/2 in. (72.4 x 41.9 cm).
The Tate Gallery, London. Depending on the source, this stark painting either shows Rossetti's interest in medieval structuring as well as his inability to execute perspective.

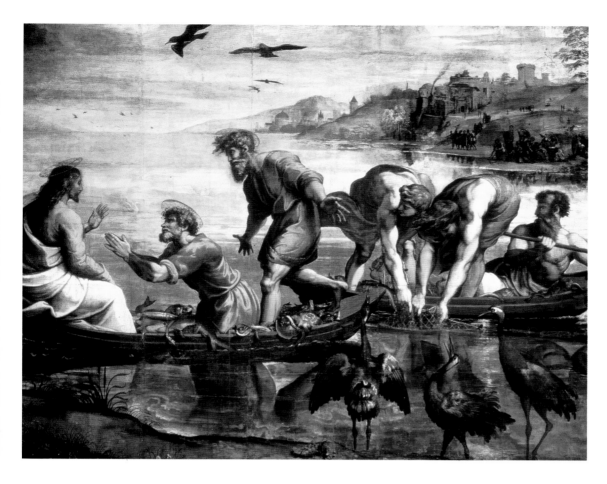

The Miraculous Draught of Fishes
Raphael, 1515; oil on paper. Victoria & Albert Museum, London.
The Pre-Raphaelites' complaint regarding Raphael was a perceived lack of sincerity; the grand gestures of his subjects seemed unnatural and overwrought, their classical repose cold.

Translation of the Bible to John of Gaunt (1847–1848), in which two of the background subjects are Chaucer and Gower, speaks of their symbolic importance to the artist. It is probably Madox Brown's influence that helped to inculcate Christian socialism (as well as what was then called "Christian idealism") into the Pre-Raphaelite philosophy.

Rossetti became aware of Madox Brown through an exhibition of his sketches shown at Westminster Hall in 1844. Later, in 1846, as Rossetti waited to enter the Academy, he met Madox Brown and begged to become his pupil. Madox Brown was possibly put off by Rossetti's intense manner; he thought he was being made the butt of a joke. However, he did accept and instruct Rossetti for a brief time.

The First Translation of the Bible into English: Wycliffe Reading His Translation of the Bible to John of Gaunt
detail; Ford Madox Brown, 1847–48; oil on canvas. City Galleries and Art Museums, Bradford.
Visually, Brown was influenced by the German Nazarenes. In subject matter he became fascinated with the medieval world through reading Chaucer, who appears at the right in this painting.

"Pre-Raphaelites"

The designation "Pre-Raphaelite" was attributed by Holman Hunt to a specific incident. In an argument with other Academy students, Millais and Holman Hunt had rejected the incongruities of form in Raphael's *Transfiguration*. Their stance sparked a bitter controversy and for their efforts, Hunt claims they were labeled "Pre-Raphaelite."

Raphael (1483–1520) was the Academy's paradigm. Indeed, one can see in the pictures of the time how close they are to the rather static quality of Raphael's *School of Athens* (1509–1512). To criticize the art of the Renaissance, however, was to lay oneself open to a remarkable amount of vituperation, as the young artists were soon to discover.

Following page:
The School of Athens
Raphael, 1509–12; fresco. The Vatican, Rome.
Raphael had come to symbolize the ideal in both painting and suitable subject matter. Here, the painter has gathered the Classical scholars together to represent the knowledge of the pre-Christian world.

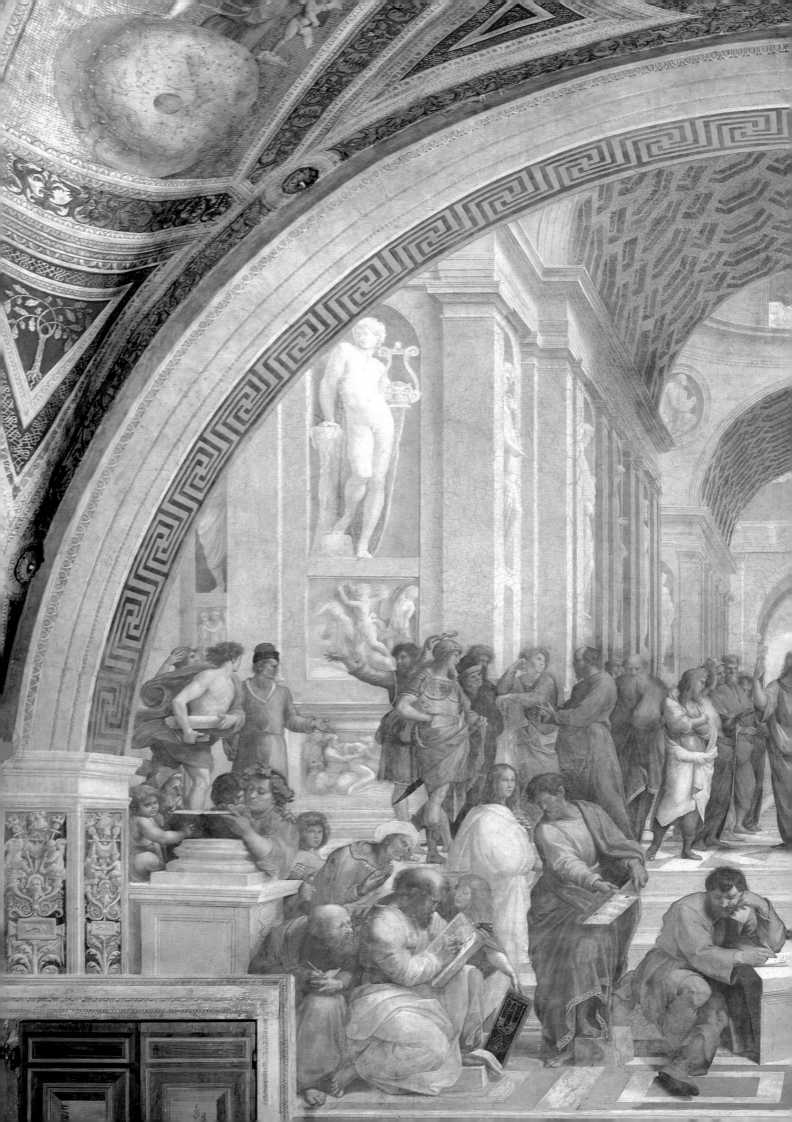

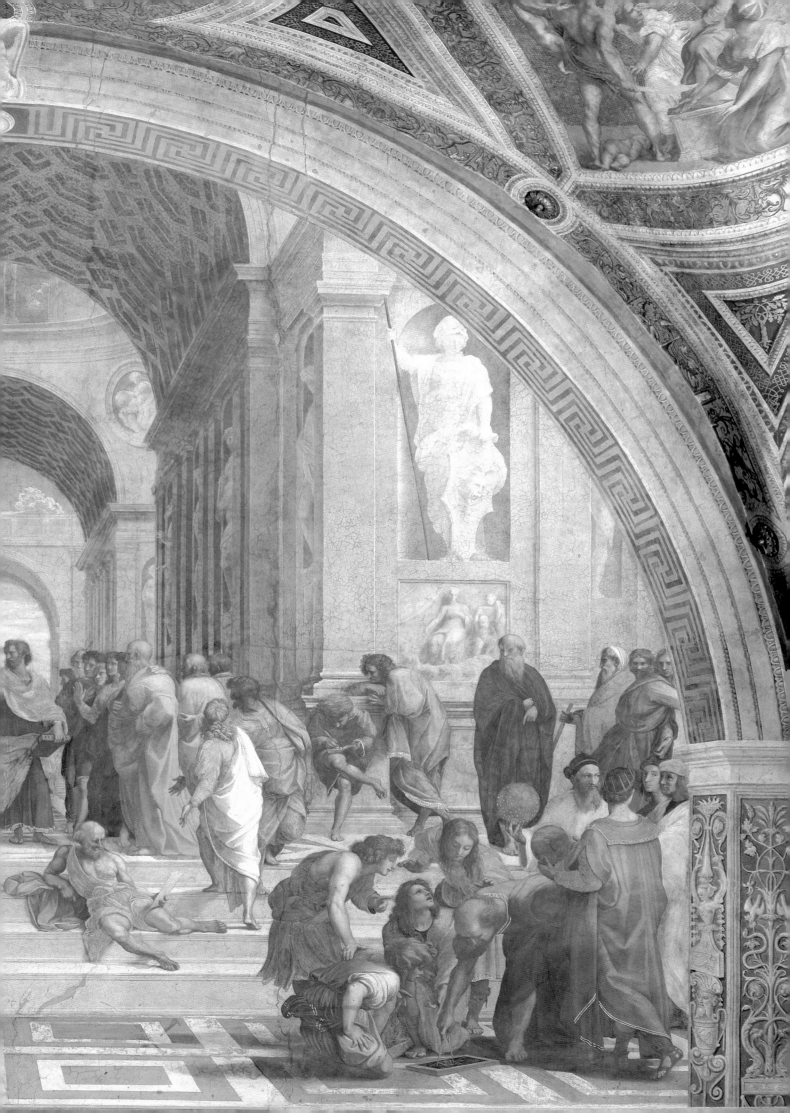

Scenes from the life of St. Augustine

Benozzo (di Lese) Gozzoli, c. 1463; fresco. San Gimignano, S. Agostino and Collegiata. Like this fresco, the majority of Gozzoli's work had to be viewed *in situ*. Aside from a small selection of paintings at the National Gallery in London (some of which were ill-used by popular taste), the young artists were largely exposed to the early Italian masters through engravings.

In addition to Raphael-like "perfection," muted colors were the prevailing aesthetic. Even Old Masters were doctored to taste. Of a certain Titian hanging at the National Gallery, Holman Hunt recalled, "It was darker in tone than it is now. The dilettanti of the early century disliked bright pictures, and the dealers suited their taste with a liberal coating of tobacco decoction and other more damaging washes. About six years later [in 1847], the picture was cleaned, and everyone was startled on seeing the difference, many declaring in the newspapers that the work, with others so treated, was absolutely ruined." Holman Hunt's teacher, the portraitist Henry Rogers, had shown him how to affect this fashion by converting the natural greens of a landscape into socially acceptable ochres and browns.

Instead of bowing to the these trends, the Pre-Raphaelites chose to favor earlier painters such as Sandro Botticelli (1445–1510), a probable pupil of Fra Filippo Lippi whose pictures, *Birth of Venus* (1486) and *Allegory of Spring* (1478), are among his most celebrated works; and Benozzo (di Lese) Gozzoli (1421–1497), a collaborator to Fra Angelico, whose *Procession of the Magi* (1459) is well known. These so-called primitives were a predominant influence to the Pre-Raphaelites for they represented an honesty that the young painters felt the High Renaissance style of Raphael lacked.

In the Brotherhood's journal *The Germ*, Gozzoli was singled out as having portrayed grape gatherers in a manner that was "the most elegant and graceful imaginable." Although much of his work, especially frescoes, remained in Italy, some pictures could be found in London, in the National Gallery. It was to these, and to engravings of distant and unapproachable pictures, that the Pre-Raphaelites looked for inspiration. (Later, in the 1850s, after the Pre-Raphaelites had awakened a taste for "bright" pictures, many works of these masters were collected by Sir Charles Eastlake for the National Gallery.)

Thus, in 1848, John Everett Millais, William Holman Hunt, and Dante Gabriel Rossetti swore to uphold the precepts of a Pre-Raphaelite Brotherhood. These were still somewhat vague but would soon be committed into canon by Rossetti's brother William Michael. Notable among them were "developing such *ideas* as are suited to the medium of fine art, and of bringing the arts of form into general unison with what is highest in other arts, especially poetry." The painters were determined to "study Nature attentively" and exclude "what is self-parading and learned by rote." It was their intention, according to William Michael, "To produce thoroughly good pictures and statues."

Perhaps the most influential factor in the creation of the Brotherhood was that all the Brothers were young and keenly idealistic. They felt that English painting, particularly as taught and exhibited at the Royal Academy, had become lackluster and prosaic. Other than that, Rossetti fancied himself a libertine in the mold of Byron; Holman Hunt was so conscientious that he was nicknamed "the Mad Hatter" (or, more simply, the Mad); and Millais was simply absorbed with painting. The promotion of moral or social good which is often attributed to Pre-Raphaelitism was actually nothing new; it had been present in other schools of English art, notably that of William Hogarth, for some time. What the Brothers brought was a new way of looking at color and form.

After his brother William Michael (whose artistic sensibilities had yet to evolve), Rossetti

brought into the fold a young man named James Collinson (1825–1881), of whom he had great hopes. Collinson had become acquainted with the Rossetti women through the Church. Earnestly caught up in the Oxford movement, he had converted to Catholicism, but then had returned to High Anglicanism. His picture of social significance, *The Charity Boy's Debut*, had been exhibited in 1847. Hunt himself brought in sculptor Thomas Woolner (1825–1892) and Frederic George Stephens (1828–1907), who became a critic and poet.

Throughout its decades of influence, there would only be seven initiates to the Brotherhood itself. Of them, Woolner was successful but never as successful or famous as the first three; Collinson was tormented by religion; and Stephens' principal task for the group would be the caretaking of Holman Hunt's muse, the notorious Annie Miller. Others who sympathized with their cause were the painters Charles Allston Collins, William Bell Scott, the aforementioned Madox Brown, as well as Rossetti's sister, Christina Georgina (who was, at the time, engaged to Collinson).

Rossetti, Millais, and Holman Hunt were to unveil the first Pre-Raphaelite pictures at the 1849 Academy Exhibition. They were Rossetti's *The Girlhood of Mary Virgin* (which featured a young and pensive Christina), Millais' *Isabella*, and Holman Hunt's *Rienzi* (for which Millais was one of the models). All three were signed "P.R.B." after the artists' names, the meaning of which at that point was not generally understood.

As the time for the Exhibition drew near, however, Rossetti chose instead to hang *The Girlhood of Mary Virgin* at an Exhibition at the Hyde Park Gallery. William Michael Rossetti later told Holman Hunt that his brother chose to do so because he was afraid of having his picture rejected by the Academy. Hunt was irritated, however, in part because by doing so Rossetti had stolen a march on Millais and himself, since the Gallery opened five days sooner than the Academy Exhibition. In this way, *The Girlhood of Mary Virgin* became the first picture of the Brotherhood to be displayed, and Rossetti was identified as the founder of a new school of painting.

In spite of this contretemps, all three Brothers fared reasonably well in their respective notices given by the *Athenaeum*. Rossetti was described as—while "young in experience, new to fame"—having painted a picture, "creditable to any exhibition." Millais and Holman Hunt were found to have "much ability and spirit," although they were cautioned to desist from "a clever revival of the merely curious."

In addition, there was something of a mixed financial success for the Brothers. In his autobiography Holman Hunt states that while Rossetti's picture was bought for eighty guineas by the Marchioness of Bath and Millais' was purchased for £150 by three tailors, who also threw in a new set of clothes, his own *Rienzi*, though generously praised by the renowned author Edward Bulwer-Lytton, had not sold.

The Girlhood of Mary Virgin

Dante Gabriel Rossetti, 1848; oil on canvas; 32 3/4 x 25 3/4 in. (83.2 x 65.4 cm). The Tate Gallery, London. Rossetti refrained from exhibiting at the Royal Academy, preferring an "open" show that, coincidentally, preceded the Academy's by five days and insured his reputation as the founder of a new school of painting.

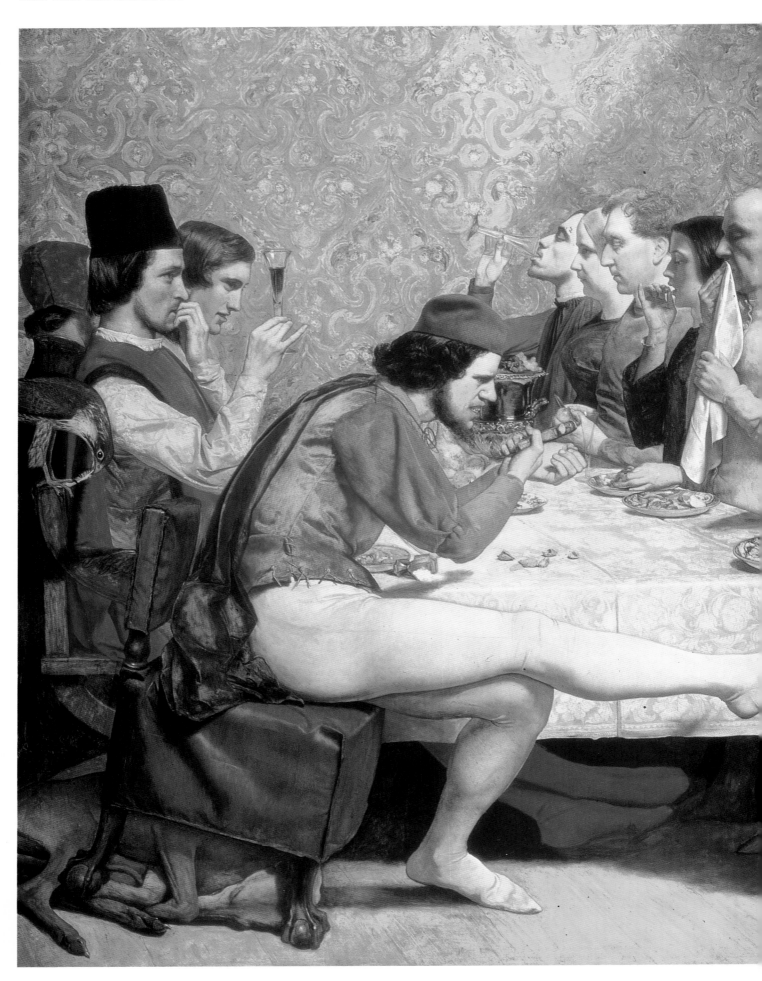

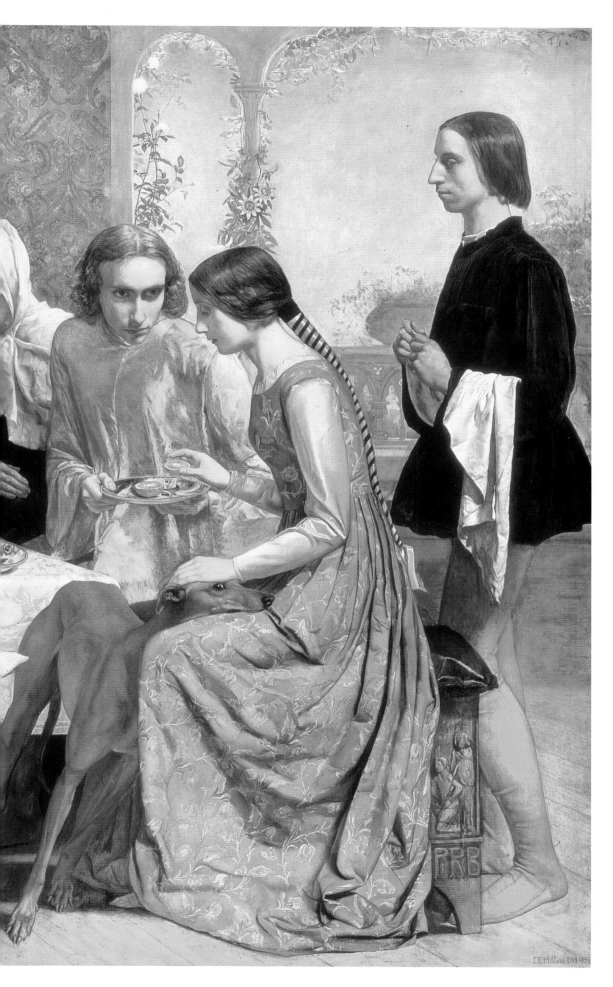

Lorenzo and Isabella (Isabella)

Sir John Everett Millais, 1849; oil on canvas; 40 x 57 in. (101.6 x 144.8 cm). Walker Art Gallery, Liverpool. This work was among the first three Pre-Raphaelite pictures shown at the 1849 Academy Exhibition, which also included Rossetti's *The Girlhood of Mary Virgin* and Holman Hunt's *Rienzi* (for which Millais was one of the models).

The Renunciation of Queen Elizabeth of Hungary

Collinson, James, 1850; oil on canvas; 47 3/8 x 71 1/2 in. (121 x 181.6 cm). Johannesburg Art Gallery, Johannesburg.

For James Collinson, 1850 was a critical year. After exhibiting this painting at the Academy and sharing in the harsh criticism directed at the Brotherhood, he departed to a Jesuit monastery, where he remained for four years.

The Germ

In 1849, in an earnest but misguided attempt to make money, the brethren decided to start a journal. *The Germ*, which was to promote the cause of Pre-Raphaelitism, was a financial failure from the start, and that it lasted four issues is due to the printer's assuming costs, with the provision that his son's poetic efforts be included. (To do him justice, the young poet, J. L. Tupper, was not bad at all and went on to be published in various collections.) In *The Germ*, the Brothers and their friends included articles, poems (Stephens wrote pseudonymously as Laura Savage), and engravings. *The Germ* provided the first showcase for Rossetti's "The Blessed Damozel," which he would continue to revise for the greater part of his life.

It was within this short-lived literary effort that Christina Rossetti's work was first introduced. Under the pseudonym Ellen Alleyn, she published the following poem.

AN END

Love, strong as death, is dead.
Come let us make his bed
Among the dying flowers
A green turf at his head;
And a stone at his feet,
Whereupon we may sit
In the quiet evening hours.

He was born in the spring,
And died before the harvesting.
In the last warm summer day
He left us;—he would not stay
For autumn twilight cold and grey.
Sit we by his side and sing
He is gone away.

To few chords, and sad, and low,
Sing we so.
Be our eyes fixed on the grass,
Shadow-veiled, as the years pass,
While we think of all that was
In the long ago.

The jarringly desolate poem was perhaps so because of her disintegrating relationship with James Collinson. Certainly for Collinson, 1850 was a remarkable year: he would exhibit his first Pre-Raphaelite picture, *The Renunciation of Elizabeth of Hungary,* have his engagement to Christina broken, and enter a Jesuit monastery. Although he would exhibit pictures off and on for the next seventeen years, his promise as a Pre-Raphaelite Brother would never be fulfilled.

Christina's aspect may have had something to do with the break-up. Although asserting that she was, indeed, lovely in youth, her brother William Michael provided this curious disclaimer: "She was one of the last persons with whom anyone would feel inspirited to take a liberty, though one might, without any sort of remonstrance, treat her as the least important of womankind."

In 1850 Rossetti exhibited an early masterpiece, *Ecce Ancilla Domini (The Annunciation).* Although William Michael Rossetti stated that his brother used a series of models for the Virgin, the thin frame and the disquieting facial expression—one of unreadable but piercing intensity—belonged in fact to their sister.

Disaster

Unfortunately, Rossetti had compounded his faux pas of the previous year by exhibiting once again outside the Academy; he also let drop the nature of the mysterious initials "P.R.B." to a sculptor named Munro, who told a journalist, who in turn promptly told all of London.

Millais had submitted for exhibition the memorable and provocative *Christ in the House of His Parents*; Holman Hunt, the ambitiously titled picture, *Christian Priests Escaping from Druid Persecution.* The reaction at the Academy Exhibition was singular condemnation, the word "revolting" occurring with startling regularity in several of the notices. One of Millais' most vituperative critics was novelist Charles Dickens, who denounced *Christ in the House of His Parents* as as "commonplace and irrelevant." For an artist as used to accolades as Millais, this must have been a tremendous shock. Certainly, Millais' adoring parents were taken aback, and blamed Rossetti for his convenient lack of presence during the controversy.

It was in this time that the Pre-Raphaelite Brotherhood truly suffered for their beliefs. Collinson left; Stephens abandoned painting to become a critic. *The Germ* was terminated, leaving the printer with the seemingly astounding debt of £33.

One comfort to the Brothers, however, was the discovery of romance and passion. Through a Pre-Raphaelite associate named Walter Deverell, Rossetti had met an obliging young beauty named Elizabeth Eleanor Siddal, who told him she would consent to model. (Siddal had actually been noticed by the poet William Allingham, working in her father's shop.) She was soon joined as Pre-Raphaelite muse by Annie Miller, an illiterate semi-urchin of fifteen whom Holman Hunt had discovered. These two women would inspire the young artists to their first glories, as well as provide them with romance—and tragedy—in the years to come.

In the darkest hours of 1850 and 1851, Millais, Holman Hunt, and Rossetti clung still to their principles and continued to paint amidst poor notices, little knowing that theirs was soon to become the prevailing aesthetic.

Christ in the House of His Parents (The Carpenter's Shop)
Sir John Everett Millais, 1850; oil on canvas; 33 x 54 in. (83.8 x 137.2 cm). The Tate Gallery, London. This painting had the misfortune of being excoriated by the great Charles Dickens, who declared it "commonplace and irrelevant," only one of the many bad notices in the storm that greeted the young painters of the Brotherhood.

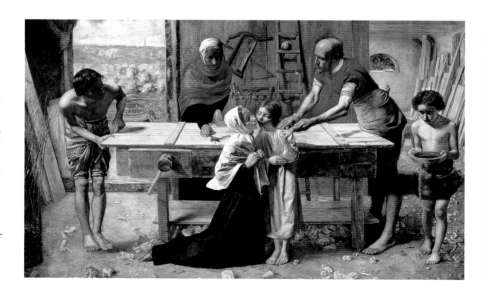

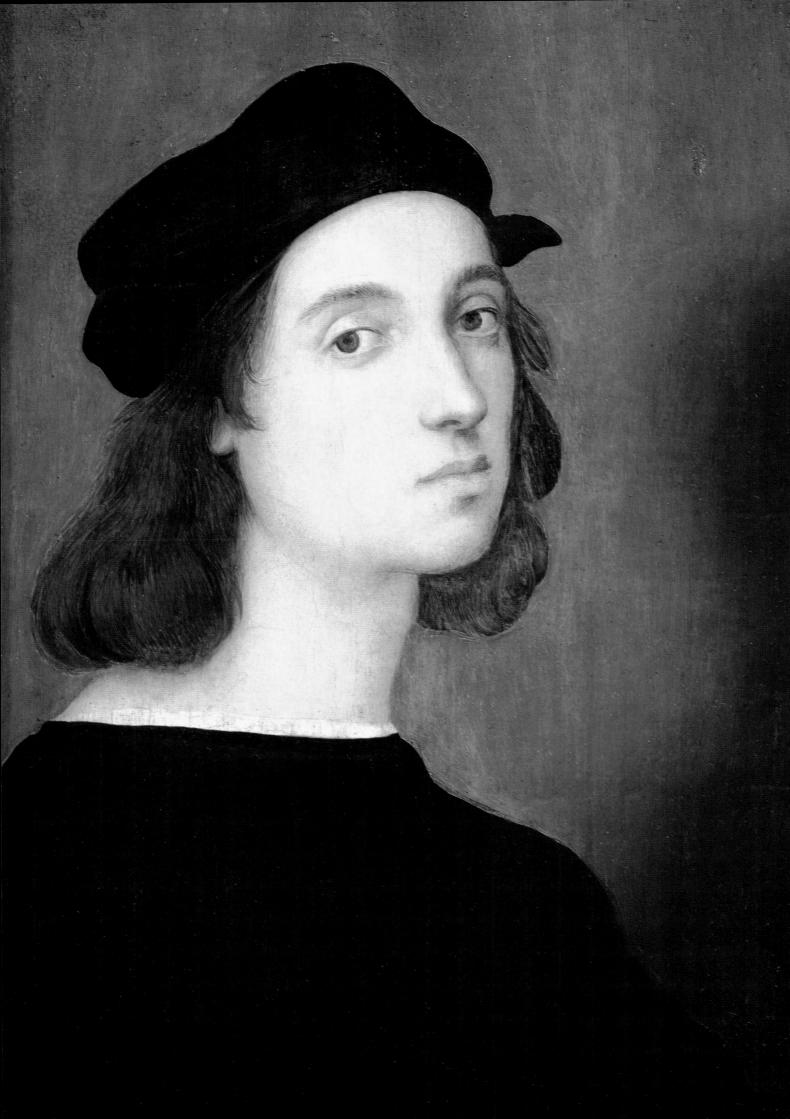

The Drop Gate

John Sell Cotman, c. 1826; oil on canvas; 13 x 10 in. (33 x 25.4 cm). The Tate Gallery, London. Cotman was one of the founders of the Norwich School, as well as having been the young Rossetti's drawing instructor. He was particularly well known for his watercolors.

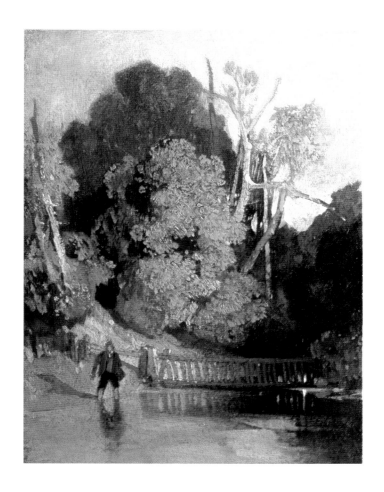

Self-Portrait

Raphael, c. 1506; oil on canvas. Uffizi, Florence. Raphael was one of the three great painters of the Italian Renaissance; the others were Michelangelo and Leonardo da Vinci. Like the Pre-Raphaelites, he was the youngest of his peers.

Cornfield at Ewell

*William Holman Hunt,
1846; oil on board; 8 x 12
1/2 in. (20.2 x 31.8 cm).
The Tate Gallery, London.*
While Millais won prizes
and adoration at an early
age, Holman Hunt was
forced to persevere in a
highly critical atmosphere.
Only the fact that he
spent all his money on
art lessons convinced
his family of his sincerity.

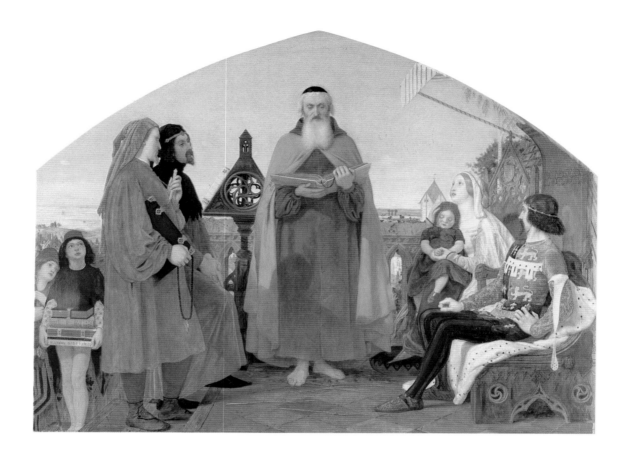

**The First Translation of the Bible
into English: Wycliffe Reading His
Translation of the Bible to John of Gaunt**
*Ford Madox Brown, 1847–48; oil on canvas; 47 x 60 1/2 in.
(119.4 x 153.7 cm). City Galleries and Art Museums, Bradford.*
This painting reflects Brown's incipient socialism.
Celebrated English reformer John Wycliffe (1328–
1384) was, through his beliefs and work, a champion
of the people against the abuse of the church.

Lorenzo and Isabella (Isabella)
*detail; Sir John Everett Millais, 1849;
oil on canvas. Walker Art Gallery, Liverpool.*
The wedding guest polishing off his wine in the back-
ground is Dante Gabriel Rossetti, whose lusty appetite
appears to have been captured by this early portrait.

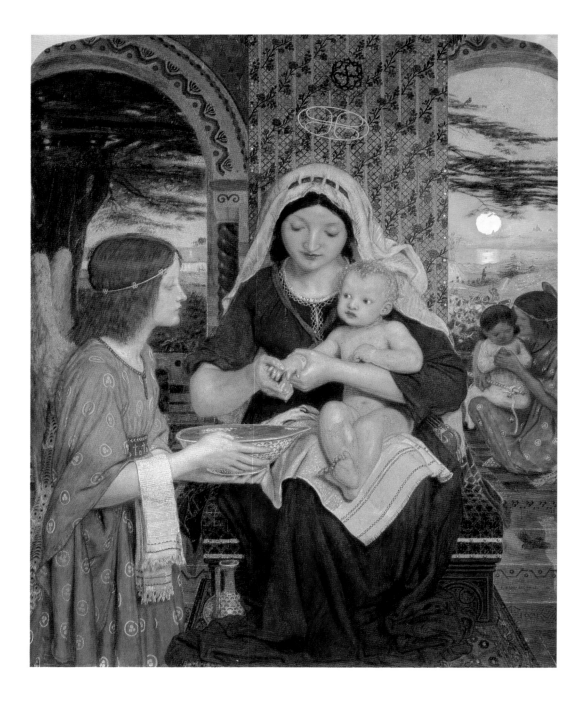

Our Lady of Good Children

Ford Madox Brown, 1847–61; watercolor;
30 3/4 x 23 1/4 in. (78.1 x 59.1 cm). The Tate Gallery, London.
Like many Pre-Raphaelite sympathizers. Brown's style
was often reminiscent of the medieval period. However,
the shape of their faces gave his people a "modern" look.

Following page:
The Haunted Manor
William Holman Hunt, 1849; oil on board;
9 3/16 x 13 1/4 in. (23.3 x 33.7 cm). The Tate Gallery, London.
Ruins and other manifestations of Gothic decadence
were the rage of the time. Here, the young Holman
Hunt has captured this guilty pleasure obliquely but well.

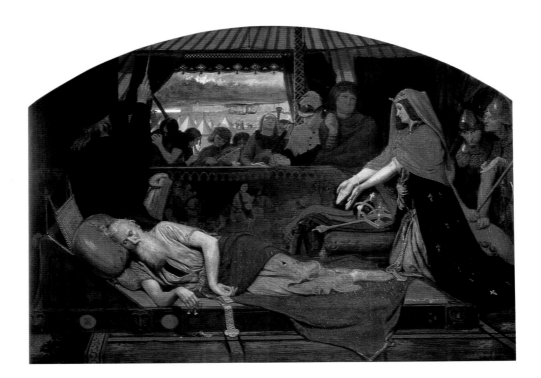

Lear and Cordelia
Ford Madox Brown, 1849–54; oil on canvas;
28 x 29 in. (71 x 99.6 cm). The Tate Gallery, London.
This painting from a Shakespearean subject received poor notices
when it was viewed in America. Throughout his career, Brown
was overshadowed by the younger painters of the Brotherhood.

1851-1855: RUSKIN AND REACTION

The contempt of the public and the critical community for Pre-Raphaelite paintings had been growing with each season the work was exhibited. By 1851 commentary on the Academy Exhibition had grown vitriolic. The *Athenaeum*'s criticism for these artists' entries was typical of the many scathing notices reserved for the hapless Pre-Raphaelites:

> We cannot censure at present as amply or as strongly as we desire to do, that strange disorder of the mind or the eyes which contributes to the rage with unabated absurdity among a class of juvenile artists who style themselves P.R.B., which, being interpreted, *Pre-Raphael-brethren.* Their faith seems to consist in an absolute contempt for perspective and the known laws of light and shade, an aversion to beauty in every shape, and a singular devotion to the minute accidents of their subjects, including, or rather seeking out, every excess of sharpness and deformity.

The critic of *The Times* also loathed the Brotherhood, claiming that the artists had, among other things, sacrificed "truth as well as feeling to eccentricity." It was this criticism that brought the influential critic and social theorist John Ruskin (1819–1900) into the fray.

The Pre-Raphaelite movement may have come to very little had it not attracted Ruskin's attention. He was one of the celebrated Victorians, the star of whose long, illustrious career had

The Awakening Conscience
detail; William Holman Hunt, 1854;
oil on canvas. The Tate Gallery, London.
According to Ruskin, "The poor girl has been sitting singing with her seducer; some chance words of the song, 'Oft in the silly night,' have struck upon the numbed places of her heart; she has started up in agony; he, not seeing her face, goes on singing, striking the keys carelessly with his gloved hand. . . ."

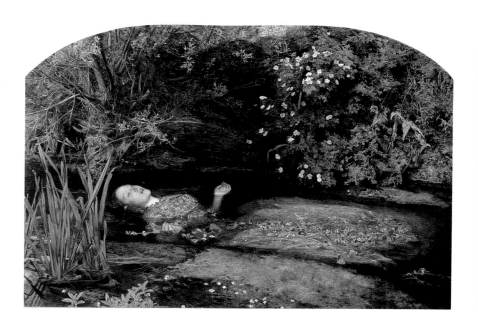

already risen with the publication of *Modern Painters*, vol. I, in 1843. Like Dickens and other "great men" of the time, he took an interest in virtually everything, including philosophy, social reform, and statesmanship. His most lively and enduring interest, for which he is well known to this day, was art.

Ruskin was born the son of wealthy parents. In expectation of some later, great accomplishment, they denied him toys and the companionship of other children but nurtured his intellect from infancy. From the age of six, he accompanied his parents on tours of European cities, and was required to sketch, to write, and to otherwise form opinions of everything he had experienced. This early training enabled him to hone his theories, among which was that the art and architecture of a nation were linked to that people's mores and morals.

After studying literature at King's College, London, he attended Christ Church, Oxford, from which he graduated in 1841. The first volume of his monumental *Modern Painters* was an eloquent and vigorous defense of the now celebrated landscape painter J. M. W. Turner. Though it came early, it was a consummate

Ophelia
Sir John Everett Millais,
1852; oil on canvas;
30 x 44 in. (76.2 x 111.8 cm).
The Tate Gallery, London.
Here, the legendary Pre-Raphaelite model Elizabeth Siddal reclined in a full bath of water to give verisimilitude to the fate of Ophelia. The doomed maiden became a favorite motif of the Pre-Raphaelites and their imitators.

Ophelia

Arthur Hughes,
1852; oil on canvas;
27 x 48 3/4 in.
(68.6 x 123.8 cm).
Manchester City Art
Gallery, Manchester.
Many renditions of
Ophelia were painted
by the Pre-Raphaelites.
Here, Hughes portrays
the hapless girl as a youth-
ful woodland sprite. The
painting was not popular
in America, where it
was exhibited in 1858.

achievement of which Ruskin remained duly proud, for in his subsequent letters, long after the publication of *The Seven Lamps of Architecture* (1849) and *The Stones of Venice* (1851–1853), he would identify himself as "Your Obedient Servant, the Author of *Modern Painters.*"

Ruskin was extraordinary, not least for the fact that he lived his life in the limelight. He once admitted that he had no private correspondence *per se*, that every letter he wrote was intended for publication. The young artists of the P.R.B. could have hoped for no greater advocate, since Ruskin was—at that time—the supreme arbiter of progressive taste.

The Scotland-born William Dyce, himself a painter who prefigured this new movement's concerns, first persuaded Ruskin to consider the Pre-Raphaelites. Like Madox Brown, Dyce had been influenced by the German Nazarenes. Ruskin did look at a picture of Millais' in the Royal Academy Exhibition of 1850, though he was as yet unenthusiastic.

Imperfect Sympathy

Ruskin's long defense of the Pre-Raphaelites began with his famous letter to *The Times*, published May 13, 1851, in which he admitted "imperfect sympathy" to their cause:

> No one who has met with any of my writings will suspect me of desiring to encourage them in their Romanist and Tractarian tendencies. . . . I am glad to see Millais' lady in blue [*Marianna*] is heartily tired of her painted window and idolatrous toilet table; and I have no particular respect for Mr. Collins' lady in white [*Convent Thoughts*], because her sympathies are limited by a dead wall, or divided between some fish and a tadpole— (the latter Mr. Collins may, perhaps, permit me to suggest *en passant*, as he is already half a frog, is rather too small for his age).

The first thrust of Ruskin's defense was the invocation of general humanity. He essentially

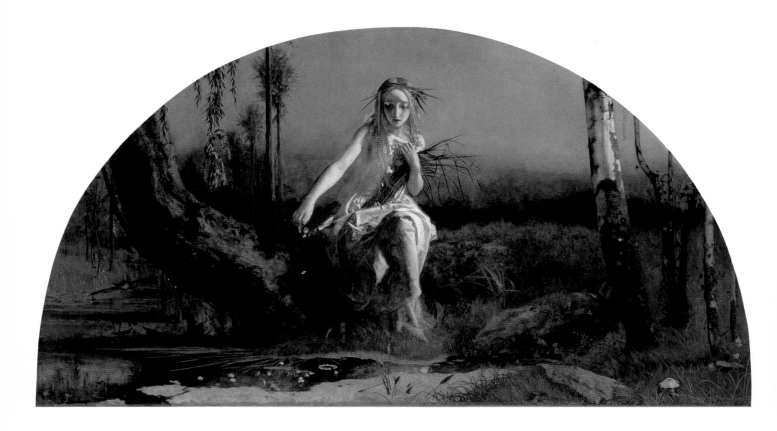

begged that the fledgling artists be treated decently, saying, "I believe these young artists to be at a most critical period of their career—at a turning point, from which they may either sink into nothingness or rise to very real greatness; and I believe also, that whether they choose the upward or the downward path, may in no small degree depend upon the character of the criticism which their works have to sustain." Ruskin maintained that "the mere labor bestowed on those works, and their fidelity to a certain order of truth (labor and fidelity which are altogether indisputable), ought at once to have placed them above the level of mere contempt"—a statement that he was to invoke time and again as works of the Pre-Raphaelites met with bitter criticism.

In his advocacy, Ruskin was no by means completely won over by the Pre-Raphaelites. The influential letters to *The Times* of May 13 as well as of May 30 repeatedly rebuke the faults of the young painters in a blow-by-blow analyses of their pictures. His main argument was with their depiction of the human figure, particularly feminine beauty: "I am perfectly ready to admit that Mr. Hunt's 'Sylvia' is not a person whom Proteus or any one else would have been likely to fall in love with at first sight; and that one cannot feel very sincere delight Mr. Millais' 'Wives of the Sons of Noah' should have escaped the Deluge. . . ." In spite of these errors on their part, Ruskin very shortly after became a patron of the Brotherhood, encouraging them in word, deed, and money.

In this time, the Pre-Raphaelites painted some of their most memorable pictures, including Millais' *Ophelia*, in which Elizabeth Siddal obliged him by sinking herself into a water-filled bath.

The Pre-Raphaelite influence began to be felt in the paintings of Arthur Hughes (1831–1915), who had met Millais in 1852 and who had painted his own *Ophelia* in that year. That year as well marked the intended departure of Thomas Woolner for Australia. Woolner, who had recently lost the commission for the Wordsworth memorial, decided instead to seek his fortune in the Australian Gold Rush. Several well-wishers, Madox Brown among them, saw him off.

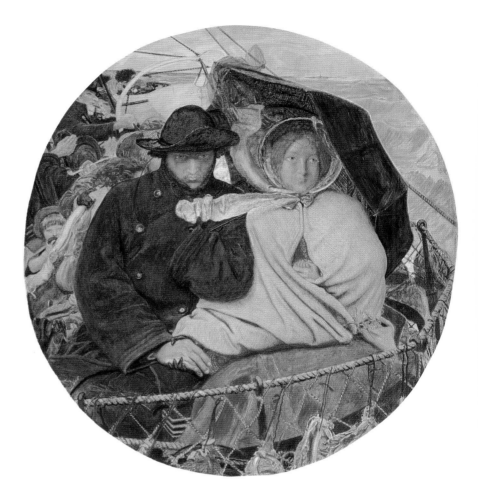

The departure had such a powerful effect on Madox Brown that he began one of his most famous pictures, *The Last of England*, in that year. *The Last of England* commemorates the English Emigration movement, in which moribund citizens of England attempted to discover their destinies elsewhere in the Commonwealth. The sorrowful couple pictured are actually Madox Brown and his wife, Emma. Of its creation, Brown wrote, "This work, representing an outdoor scene, without sunlight, I painted chiefly out of doors, when the snow was lying on the ground."

Indeed, Pre-Raphaelite ideals—which required the artists to work frequently "out of doors"—were not often easy to live by. Many were the biting insects, pouring rain storms, and other bucolic miseries encountered by the artists while conforming to the precept of painting in natural light. Arthur Hughes, whose picture *The Long Engagement* (1859) had begun in 1853 as a Shakespearean subject, *Orlando in the Forest of Arden*, felt this keenly.

The Last of England
Ford Madox Brown,
1864–1866; watercolor;
13 7/8 x 12 7/8 in.
(35.6 x 33 cm).
The Tate Gallery, London.
In one of his most famous paintings, the eyes of the painter and his wife stare out at some disappearing horizon. Here is a watercolor study of the final painting, which so successfully captured the emotion of poignant leave-taking.

The results, however, were sometimes spectacular. Millais' *Portrait of John Ruskin* (1853–1854), for example, displays the finer characteristics of a true Pre-Raphaelite painting—realistic outdoor setting, a true rendering of colors—as well as being a flattering portrayal of the critic himself. Millais' relationship with the great theorist was, at this point, surprisingly cordial, considering that Ruskin's wife Euphemia ("Effie") had fallen in love with the painter, and was determined to have him. To Ruskin's embarrassment, his marriage was subsequently annulled, on the curious grounds that it had never been consummated.

In 1851 Holman Hunt completed *The Hireling Shepherd*. He also painted a portrait of Rossetti, which proved, at least, that they were on speaking terms at the time. The relationship between Holman Hunt and Rossetti tended to be tempestuous. By November of 1853, Millais' uncontested talent had won him the title of Associate of the Royal Academy, to the dismay of his fellows.

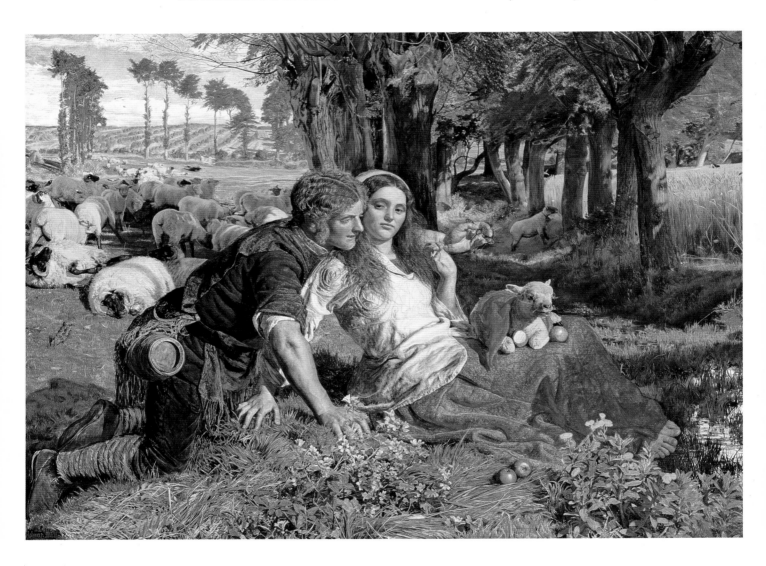

The Hireling Shepherd
William Holman Hunt, 1851; oil on canvas; 30 x 42 1/2 in. (76.2 x 107.2 cm). Manchester City Art Gallery, Manchester.
Pastoral motifs were as immensely popular throughout this period as they had been since antiquity. Holman Hunt's real subject, however, has been taken from *King Lear* and was meant to warn inattentive pastors against neglecting their flocks.

Our English Coasts ("Strayed Sheep")
detail; William Holman Hunt, 1852;
oil on canvas. The Tate Gallery, London.
Here, Holman Hunt's study of sheep, while true to Pre-Raphaelite naturalism, manages to assert personalities. Compare this to *The Hireling Shepherd*, where the strays are more obviously anthropomorphic.

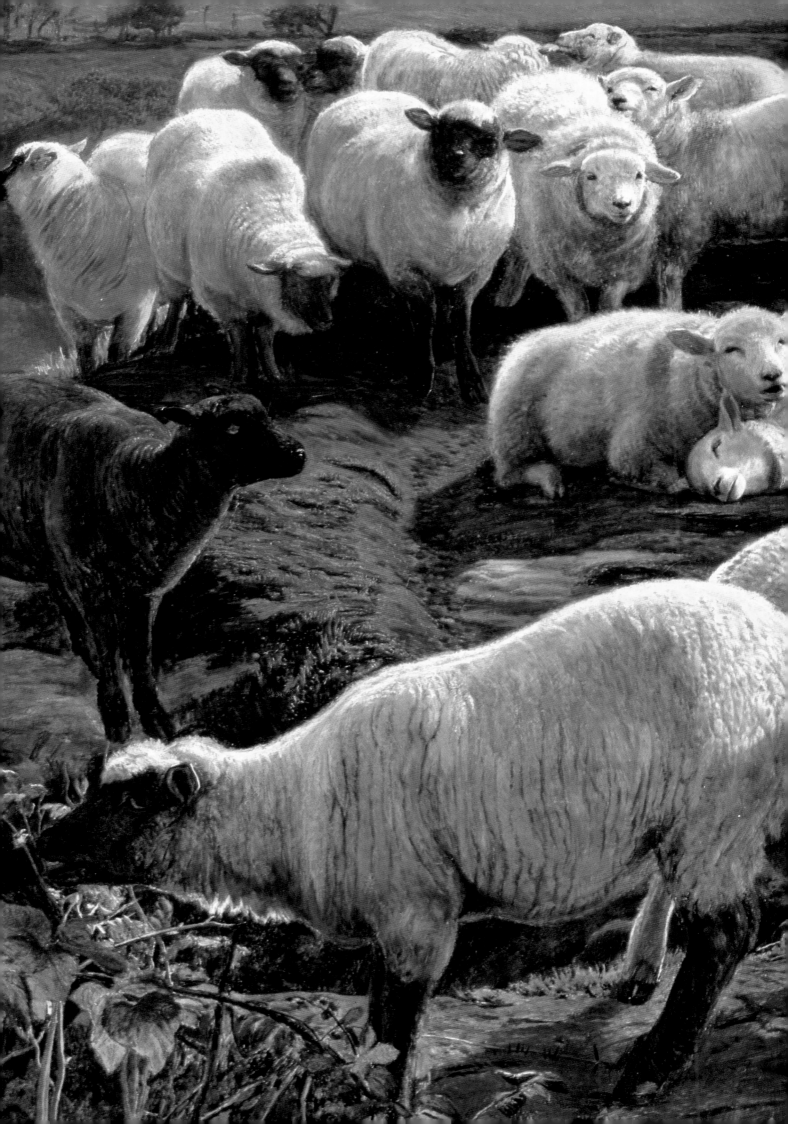

Rossetti wrote to his sister, quoting Tennyson, "So now the whole Round Table is dissolved." She responded philosophically and in somewhat strangled verse, "So rivers merge in the perpetual sea;/So luscious fruit must fall when over-ripe."

In 1854 the Rossetti family sustained a tragedy: Gabriele passed away. For years, blindness had kept him from supporting the family. His wife Frances and daughter Christina opened a day school, and William Michael helped out as best he could. (Dante Gabriel would prove himself unreliable in this respect.)

That year, Rossetti painted another subject culled from his beloved Dante, *Paolo and Francesca*. Madox Brown began teaching drawing at the Workingmen's College, Manchester, begun by the Rev. F. D. Maurice. Holman Hunt had been to Syria, where he used the Holy Land as a backdrop to create The *Scapegoat* (1854), a symbolic subject depicted in vivid colors.

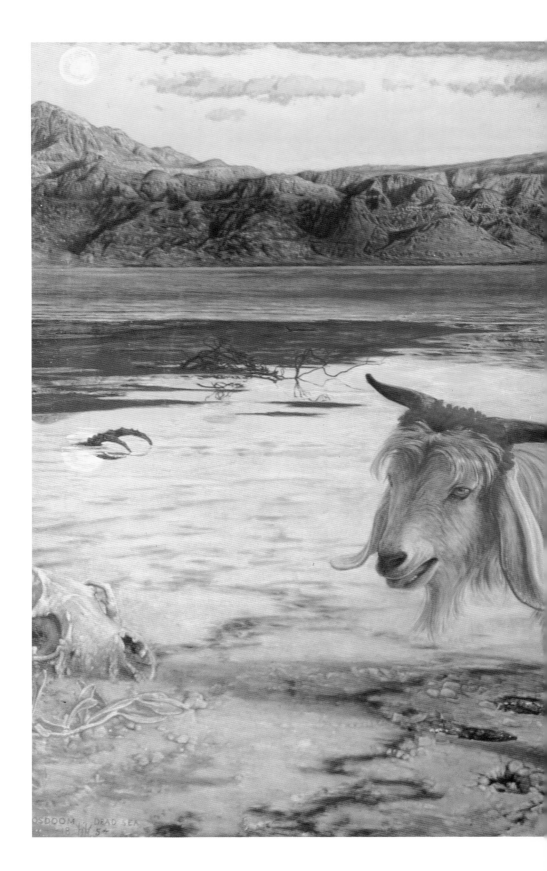

The Scapegoat

William Holman Hunt, 1854; oil on canvas; 33 3/4 x 54 1/2 in. (85 X 138 cm). Lady Lever Gallery, Port Sunlight.

A seminal Pre-Raphaelite work, this painting was the culmination of Holman Hunt's travels in Syria. Critics at the time disputed the veracity of the colors. It is notable that Holman Hunt had decided to omit a stunning rainbow that he encountered at the scene.

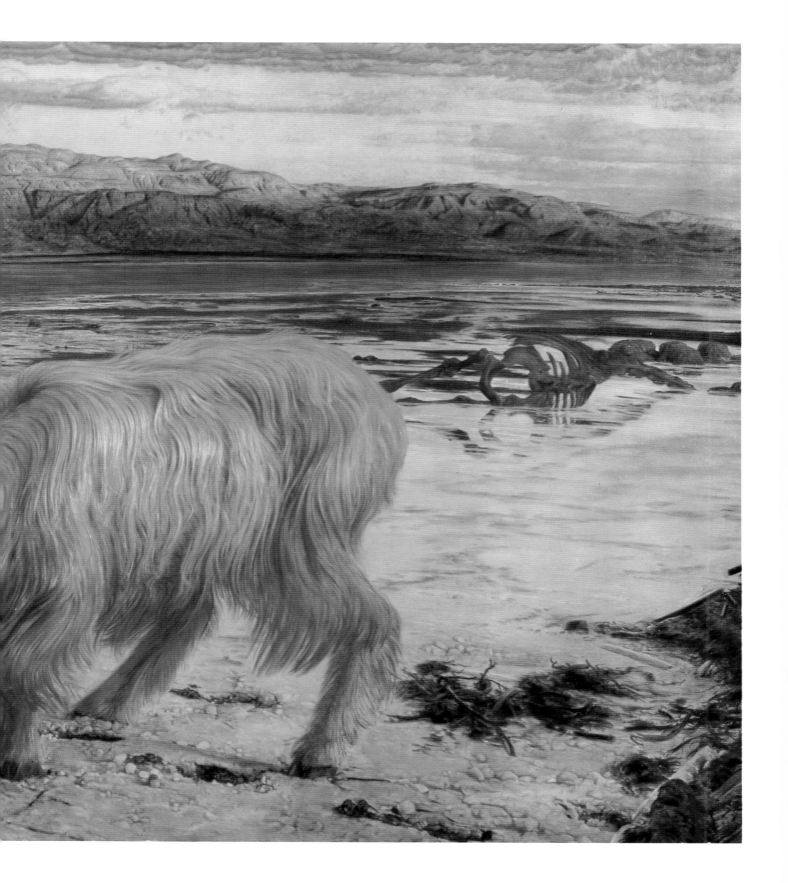

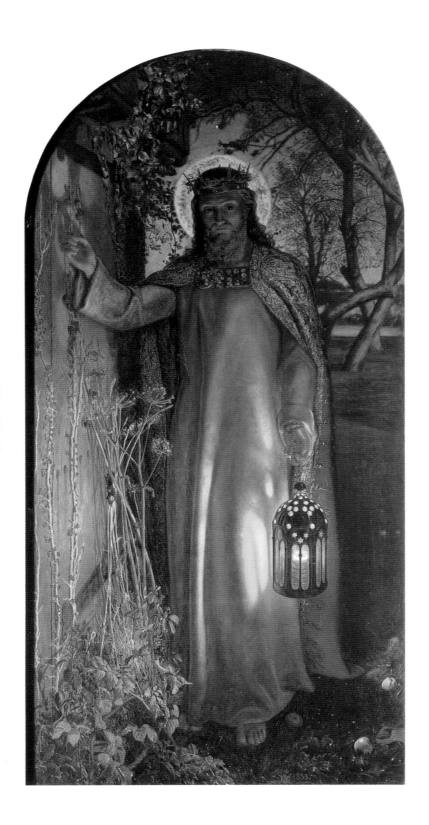

The Light of the World

William Holman Hunt, 1854; oil on canvas;
49 5/8 x 20 1/2 in. (105.4 x 58.9 cm). Keble College, Oxford.
Pre-Raphaelite imagery often baffled critics and public alike. Ruskin went to great pains to interpret this beautiful portrayal of Christ and His promise of redemption, calling it "one of the very noblest works of sacred art ever produced in this or any other age."

The Light and the Darkness

In 1854 Holman Hunt exhibited two pictures at the Academy, *The Light of the World* and *The Awakening Conscience.* Both reflected his deep religious and moral convictions. According to Ruskin, the paintings were not an immediate success, and once again he felt compelled to argue in favor of and interpret a Pre-Raphaelite picture. "I speak of the picture called 'The Light of the World,' by Holman Hunt," he said. "Standing by it yesterday for upwards of an hour, I watched the effect it produced upon the passers-by. Few stopped to look at it, and those who did invariably with some contemptuous expression, founded on what appeared to them the absurdity of representing the Saviour with a lantern in his hand." Ruskin goes on to describe the meaning of the picture in fascinating detail:

> Now, when Christ enters any human heart, he bears with him a twofold light; first, the light of conscience, which displays past sin, and afterwards the light of peace, the hope of salvation. The lantern, carried in Christ's left hand, is this light of conscience. Its fire is red and fierce; it falls only on the closed door, on the weeds which encumber it, and on the apple shaken from one of the trees of the orchard, thus marking that the entire awakening of the conscience is not merely to committed, but to hereditary guilt.
>
> The light is suspended by a chain, wrapt about the wrist of the figure, showing that the light which reveals sin appears to the sinner also to chain the hand of Christ.
>
> The light which proceeds from the head of the figure, on the contrary, is that of the hope of salvation; it springs from the crown of thorns, and, though itself sad, subdued, and full of softness, is yet so powerful that it entirely melts into the glow of it the forms of leaves and boughs, which it crosses, showing that every earthly object must be hidden by this light, where its sphere extends.

Ruskin goes on to assert that, in his opinion, "it is one of the very noblest works of sacred art ever produced in this or any other age."

Today it remains one of Britain's best-known paintings.

The second picture, *The Awakening Conscience*, was more problematic. Most critics questioned the subject matter—kept womanhood or genteel prostitution—calling it "dark." According to Ruskin, "The poor girl has been sitting singing with her seducer; some chance words of the song, 'Oft in the silly night,' have struck upon the numbed places of her heart; she has started up in agony; he, not seeing her face, goes on singing, striking the keys carelessly with his gloved hand. . . ."

The background of *The Awakening Conscience* had disturbing undercurrents, for Holman Hunt's model was, as usual, Annie Miller. During the years of their acquaintance, Hunt had become intimately and romantically attached to his foremost model; he even wished to marry her. He did not, however, feel confident that he could introduce her to his parents, since his matrimonial intentions toward Miller seemed to horrify even his bohemian friends. He thus wavered, maintaining that she receive some lessons in literacy, mathematics, and deportment before their marriage could take place. The money for these lessons was placed in a trust, administered by the hapless Stephens, from which he was obliged to borrow, on his own account, from time to time.

Miller herself had shown no inclination to monogamy, and her attitude toward being a "fallen woman" seemed to have nothing of Holman Hunt's imagined conscience. Rather, her subsequent actions imply that she must have felt he was putting up unreasonable impediments to her future security (in fact, they never married) and, if she did not want to end up on the street, that it was up to her to make it so.

Regardless of the involvement of its principals, the subject matter of *The Awakening Conscience* spoke strongly not only to Ruskin the aesthete, but to Ruskin the social reformer: "While pictures will be met with by the thousand which literally tempt to evil, by the thousand which are directed to the meanest trivialities of incident or emotion, by the thousand to the delicate fancies of inactive religion, there will not be found one

powerful as this to meet full in the front the moral evil of the age in which it is painted."

While the Brotherhood, to a keen observer such as Christina Rossetti, may have been "over-ripe," to the outside world they had awakened considerable—this time, favorable—notice. There had been a beneficent change in all their fortunes as Pre-Raphaelitism became accepted within the artistic community, even if the viewing public had not yet caught on. New artists—among them Hughes and Henry Alexander Bowler (1824–1902) and the watercolorist, John Fredrick Lewis (1805–1876)—as well as old sympathizers Dyce, Madox Brown, and Charles Allston Collins (1828–1873) were brought into the fold.

The Awakening Conscience

William Holman Hunt, 1854; oil on canvas; 30 x 22 in. (76.2 x 58.9 cm). The Tate Gallery, London. Hailed by Ruskin as a masterwork, the true story behind this painting reflected the gulf between moralists such as Holman Hunt and the fallen women they attempted to save.

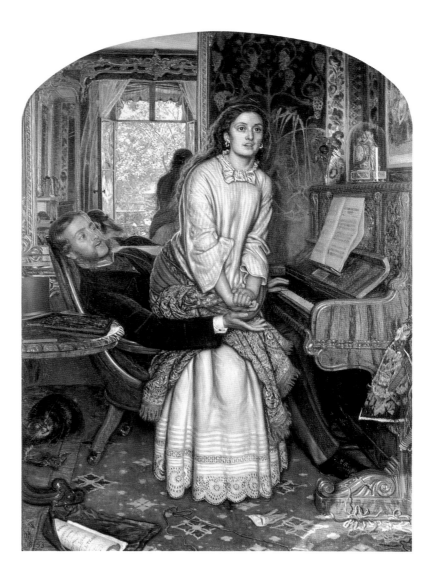

Hughes exhibited his picture *Fair Rosamund* in 1854. Siddal, Rossetti's mistress, with the encouragement of her lover and Ruskin, had also taken up pen and brush, composing both in verse and in oils. And there were more to come, as the Pre-Raphaelite influence widened. Ruskin was now able to say, "The spurious imitations of Pre-Raphaelite work represent the most minute leaves and other objects with sharp outlines, but with no variety of colour, and with none of the concealment, none of the infinity of nature. With this spurious work the walls of the Academy are half covered. . . ."

By "spurious imitation" Ruskin meant such pictures as Dyce's *Christabel* (1855), which he maintained stemmed from a false branch of the Pre-Raphaelite philosophy. Others, such as Bowler's The *Doubt: 'Can These Dry Bones Live?'* (1854–1855) were presumably within the Pre-Raphaelite character.

Millais' *Rescue*

In 1855, the same year he eloped with the former Mrs. Ruskin, Millais painted *The Rescue*. The subject is a fireman's bravery, risking his life to save others. Millais' inspiration had come from witnessing an actual fire rescue, but once again, in true Pre-Raphaelite fashion, he sought to recreate the scene by setting an actual fire in his studio. He studied the results, and made many sketches before preceding. Collins, another recipient of Ruskin's back-handed compliments, assisted Millais with the some of the painting. The result was roundly praised by Ruskin. "The Rescue," he proclaimed, was ". . . the only *great* picture exhibited this year; but this is *very* great."

Seemingly, Pre-Raphaelitism was even having an affect on its own influences. In 1856 Rossetti was to discover that the poet Robert Browning had a knowledge of early Italian art that "was encyclopaedically beyond that of Ruskin himself." This was evident one evening in 1855, when Browning was at Tennyson's reading his poem, *Fra Filippo Lippi*. Perhaps through the interest in the early Italian Renaissance, the subject of a roguish *quattrocentro* painter had suggested itself.

Madox Brown, in the meantime, continued painting in his sympathetic but nevertheless distinct style. He completed *An English Autumn Afternoon—London Outskirts* (1852–1854) and exhibited what was to be his masterpiece, *The Last of England,* at the Liverpool Academy in 1855. He did not receive—nor would he ever—the plaudits given to Millais' work. Nor was he alone. Rossetti might affect not to care, but occasionally Holman Hunt would admit that the Academy's lack of recognition did sting.

The Doubt: Can These Dry Bones Live?
Henry Alexander Bowler, 1856; oil on canvas; 24 x 20 in. (61 x 50.8 cm). The Tate Gallery, London. Bowler's painting combined the popular preoccupation with death with a Pre-Raphaelite eye for bright color and detail. While Bowler was not personally acquainted with the Brotherhood, this work shows that their influence was becoming pervasive.

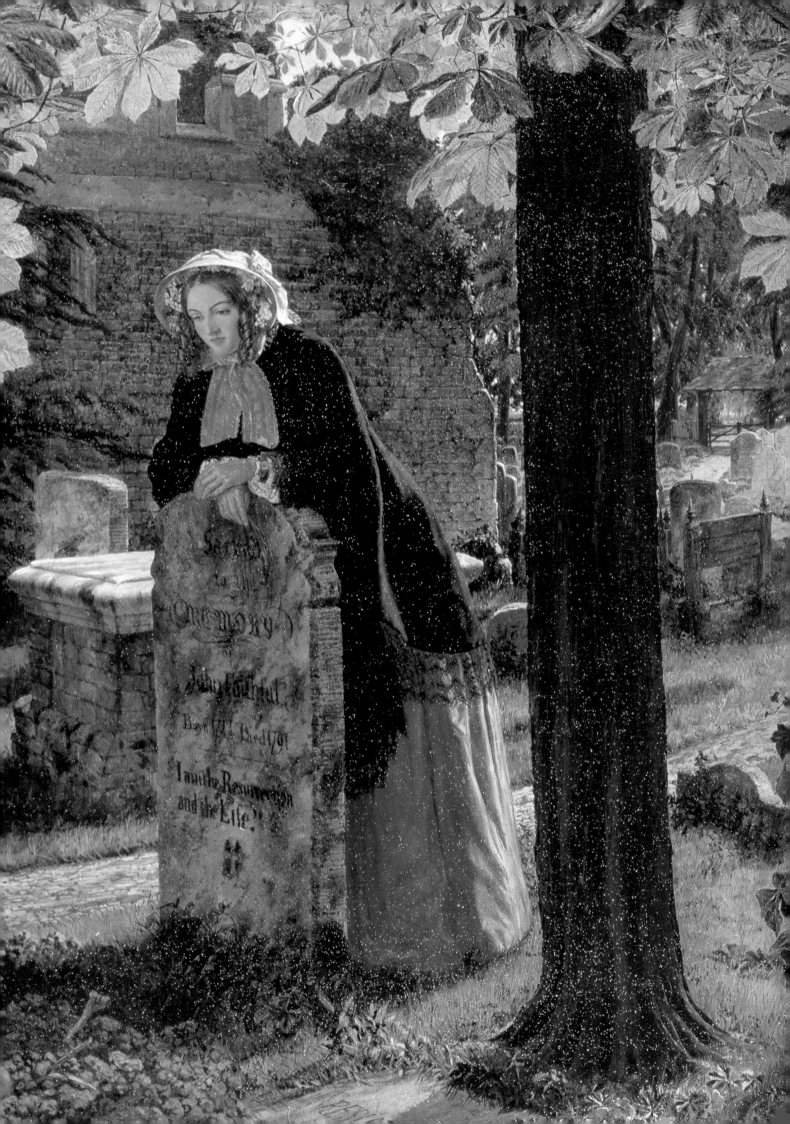

Paolo and Francesca da Rimini

Dante Gabriel Rossetti, 1855; watercolor; 9 3/4 x 17 1/2 in. (24.8 x 44.5 cm). The Tate Gallery, London. The lovers Paolo and Francesca, found in the adulterers' circle of Dante's *Inferno*, were popular subjects of the Pre-Raphaelites. Here, Rossetti has framed the poet and his guide with scenes of the famous lovers in life and death.

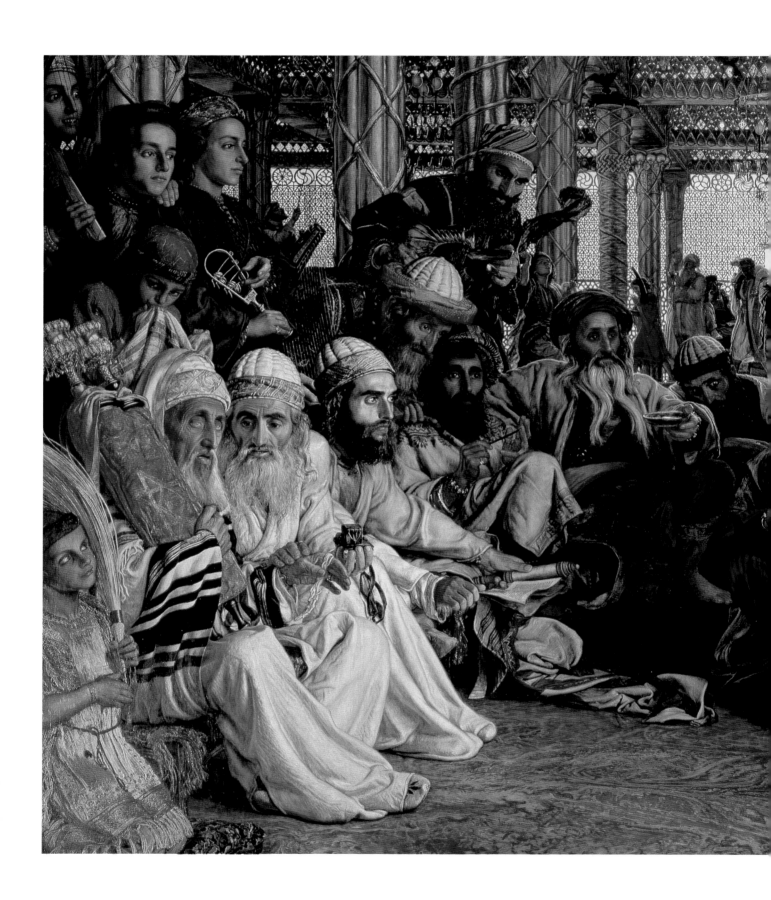

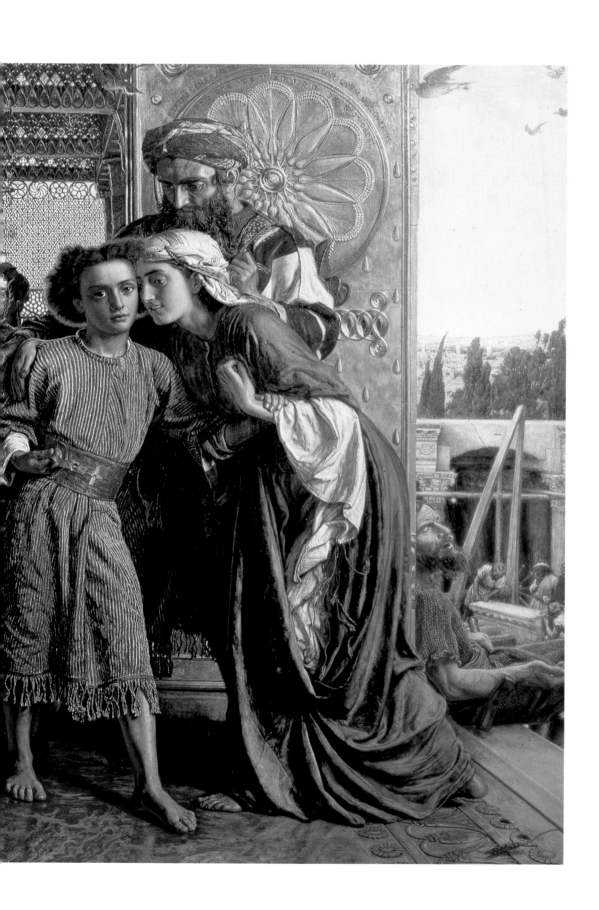

The Finding of the Young Savior in the Temple

William Holman Hunt, 1854–60; oil on canvas; 33 1/4 x 55 1/2 in. (84.4 x 141 cm). City Museum and Art Gallery, Birmingham. The lush Oriental motifs of this painting demonstrate Holman Hunt's admiration for the Holy Land. He made several trips to Syria, and these were often fraught with danger and other difficulties.

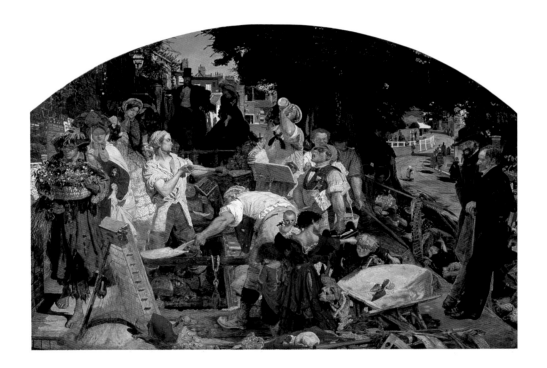

Work

Ford Madox Brown, 1852–65; oil on canvas; 53 x 77 1/8 in.
(134.6 x 195.9 cm). Manchester City Art Gallery, Manchester.
Brown's belief in Christian idealism has no better reflection than this
painting, one of the great murals of the modern age. His influence managed
to inculcate the Pre-Raphaelite movement with a social conscience.

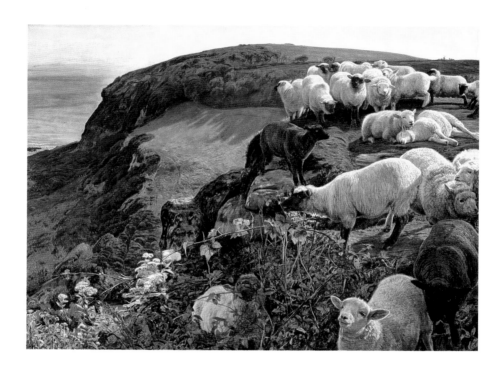

Our English Coasts ("Strayed Sheep")
William Holman Hunt, 1852; oil on canvas;
17 x 23 in. (43. x 58. 4 cm). The Tate Gallery, London.
The Pre-Raphaelites were truly English in their love of the
countryside as subject matter. But of the three Brothers, Holman
Hunt had the greatest affinity for the portrayal of animals.

CHAPTER THREE

1855-1861: ROSSETTI'S NEW CROWD

At the height of their fame, the Pre-Raphaelite Brothers were growing apart. Millais was uxorious in Scotland and Holman Hunt was painting earnestly and playing Pygmalion to Miller (without much hope). Only Rossetti seemed steady, providing the beacon to which the young and talented flocked. Thus, in the years subsequent to their arrival, the Pre-Raphaelite mixture was enriched by many new artists who came under the tutelage of Rossetti. Chief among these were William Morris and Edward Burne-Jones.

Topsy and Ned

Like the original Pre-Raphaelites, Morris and Burne-Jones came from divergent backgrounds. Morris had enjoyed an affluent upbringing in London as the son of a stockbroker; Burne-Jones had had a more modest upbringing in Birmingham, where his father had a gilding and framing business. It was through these two young men that the Pre-Raphaelite spirit would briefly revive and fluoresce into what came to be termed the Aesthetic Movement.

The two had met at Oxford, at Exeter College, in 1852. They were brought together by a transient enthusiasm for religion, and a more per-

manent love of medievalism and art. Like Millais, Rossetti, and Holman Hunt, Morris and Burne-Jones also joined a brotherhood, (simply "the Brotherhood"), but nothing lasting came of it except their friendship. Morris was given the nickname "Topsy," for his unruly hair was said to be reminiscent of that character in the popular novel from 1852 by Harriet Beecher Stowe, *Uncle Tom's Cabin*; Burne-Jones was simply and affectionately known as "Ned."

Like the Pre-Raphaelites, they too were influenced by Tennyson, Browning, and Keats as well as Ruskin; sometime in 1852, they also discovered Thomas Malory's *Morte d'Arthur* with delight. In a letter to Morris, written in 1854, Burne-Jones expressed the emotions which were to govern his destiny:

> I get frightened now of indulging in dreams, so vivid that they seem recollections rather than imaginations, but they seldom last more than a half-an-hour; and the sound of the earthly bells in the distance, and presently the wreathing of steam upon the trees where the railway runs, called me back to the years I cannot convince myself of living in.

The imagery that this passage conveys is emblematic of the painting he was to do for the rest of his life.

The two artists became inseparable, traveling to France together in 1855, on Morris' money. At Oxford, they banded together with fellows of a like mind. While Morris wrote verse as well as painted, Burne-Jones, like Millais, was foremost a painter who found all his expression in art. Sometimes

Arthur's Tomb

Rossetti, Dante Gabriel, 1860; watercolor; 9 1/4 x 14 1/2 in. (23.4 x 36.8 cm). The Tate Gallery, London. Rossetti was known for his unusual watercolor style, which involved mixing as little water as possible. The result was opaque "burned-in" color, reminiscent of crayon.

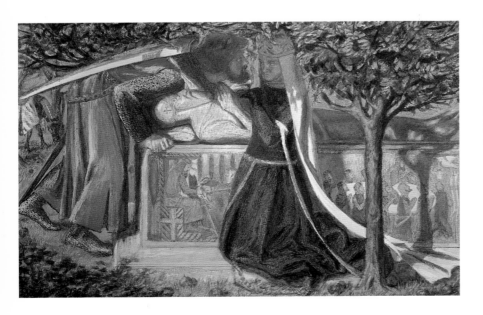

The Last Sleep of Arthur
detail; Sir Edward Coley Burne-Jones, 1881–88; oil on canvas. Museo de Arte, Ponce, Puerto Rico. While at Oxford, both Morris and Burne-Jones fell under the spell of Arthurian legends as told in Sir Thomas Malory's *Morte d'Arthur.* Burne-Jones and others never tired of painting scenes from the myth cycle.

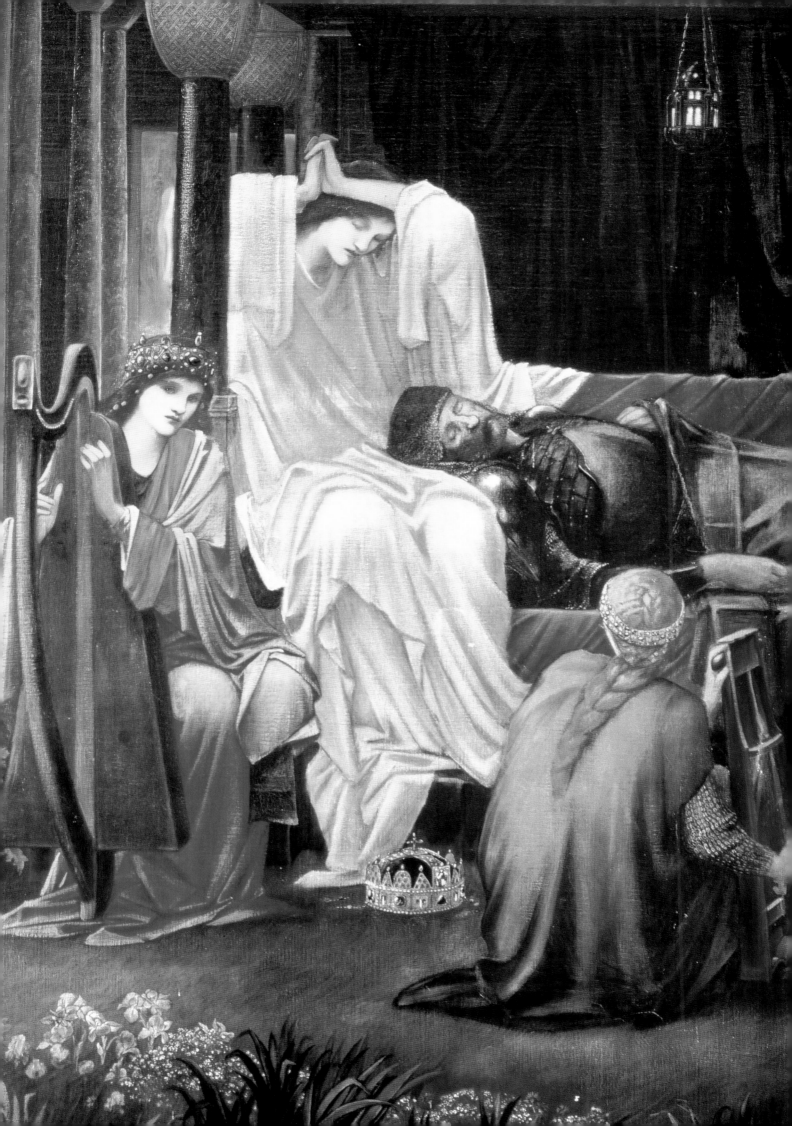

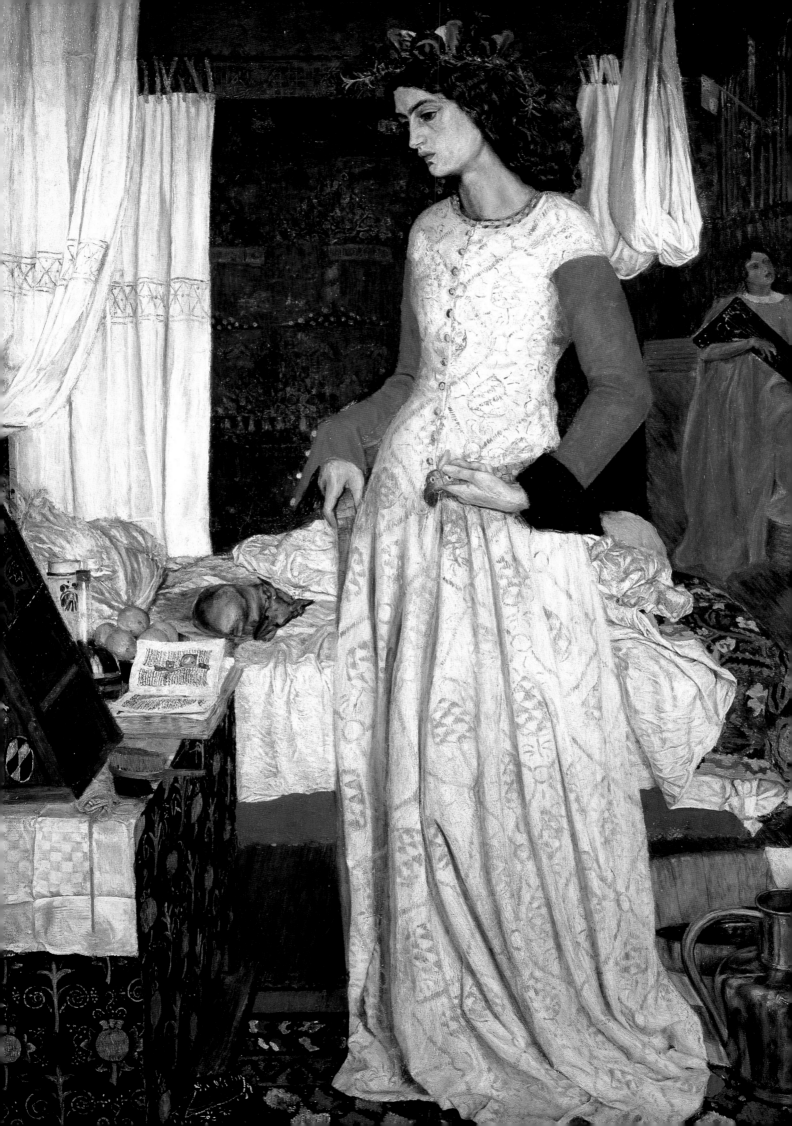

Burne-Jones became gloomy; similar to the Rossettis, he was inclined to melancholia. Morris, however, was in youth very much as the poet William Butler Yeats would later describe him:

> A never idle man of great physical strength and extremely irascible—did he not fling a badly baked plum pudding through the window upon Xmas Day?—a man more joyous than any intellectual of our world, called himself "the idle singer of an empty day" created new forms of melancholy, and faint persons, like the knights & ladies of Burne Jones, who are never, no, not once in forty volumes, put out of temper. A blunderer, who had said to an unconverted man at a socialist picnic in Dublin, to prove that equality came easy, "I was brought up a gentleman and now, as you can see, associate with all sorts," and left wounds that thereby rankled after twenty years, a man of whom I have heard it said, "He is always afraid that he is doing something wrong, and generally is," wrote long stories with apparently no other object than that his persons might show one another, through situations of poignant difficulty, the most exquisite tact.

Perhaps there was something whimsical in Morris' nature that made of him a particular figure of fun, for throughout his life he was incessantly caricatured by his fellow artists, especially by his dear friend Burne-Jones. Many of these cartoons show a rotund figure, with wild hair smashed down by a rumpled hat, acting out in a fit of pique. Most of the pictures were affectionately drawn, and for that reason have been preserved.

Although Morris had initially introduced his friend to the work of the Pre-Raphaelites, it was Burne-Jones who first made the acquaintance of Rossetti himself. In 1855 Burne-Jones had become intrigued by Rossetti and his work after seeing his illustrations in William Allingham's

La Belle Iseult

William Morris, 1858; oil on canvas; 28 1/2 x 20 in. (71.1 x 50.8 cm). The Tate Gallery, London.
The model for this painting was Jane Burden, whom Morris married in 1859. In spite of his rampant creative energies, Morris was not confident of his abilities as a painter.

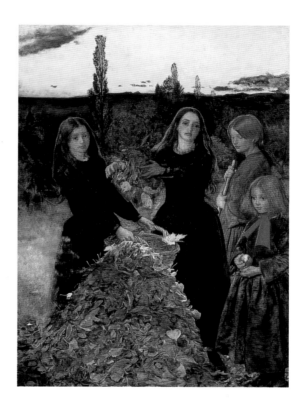

Autumn Leaves
Sir John Everett Millais, 1856; oil on canvas; 40 1/2 x 28 1/2 in. (102.9 x 72.4 cm). Manchester City Art Gallery, Manchester.
Among the innovations of the Pre-Raphaelites was a new standard for feminine beauty. Here, Millais displays a trio of such beauties in a vividly colored and sentimental subject.

book of poetry, *The Maids of Elfenmere*. Burne-Jones subsequently attended a drawing class that Rossetti was giving in London, and the two struck up a master-pupil relationship. This resulted in Rossetti's having his usual influence on the young Burne-Jones: delightful talk of art and poetry, nights of music halls and liquor, and dreams of glory. Burne-Jones was sufficiently moved by Rossetti to actually leave Oxford without earning a degree, move to London, and live for art.

Although some came to grief through Rossetti's agency, Rossetti's advice to Burne-Jones did no lasting harm at all—in fact, it was quite good. Within a year, he had acquired an influential patron: William Graham, an affluent Scottish tradesman who was also a liberal Minister of Parliament. Graham would remain a friend and patron of Burne-Jones until the end of his life. Which is not to say that Burne-Jones did not have many lean years; but in the end he was the better for it, having traveled—at Rossetti's suggestion—to Italy. There, he encountered the original works of Botticelli and other Italian Masters, which worked their magic on his fevered imagination as they had on the Pre-Raphaelites who had gone before him.

Meanwhile Morris had graduated from Exeter in 1855. He too came to London and went to

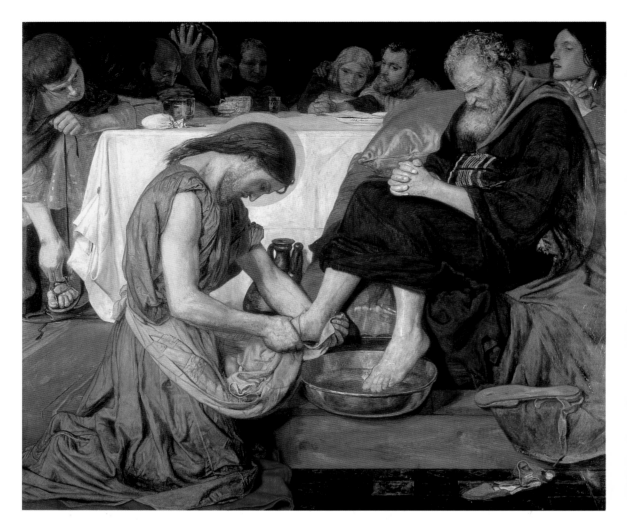

Jesus Washing Peter's Feet (Christ Washing Peter's Feet)

Ford Madox Brown,, 1852–1856; oil on canvas; 46 x 52 1/2 in. (116.8 x 133.3 cm). The Tate Gallery, London. The style of this painting bears a resemblance to *The Kiss of Judas* by the quattrocento master Giotto. It is a quiet but masterful study of one of the New Testament's most revealing moments.

work for the architect George Edmund Street (where he was to meet Philip Webb), and the rough-and-ready companionship that he and Burne-Jones had always enjoyed resumed. Now it was further enlivened by Rossetti, Hughes, and others of the Brotherhood.

While the Pre-Raphaelite Brotherhood was pretty much dissolved by 1857, the three principals did remain active. A year earlier, Millais had exhibited *Autumn Leaves* and received his usual praise; Arthur Hughes exhibited *April Love*. Rossetti was busy both with his work (he had finished *The Wedding of St. George and the Princess Sabra*) and with playing muse to the younger set. That year, Rossetti and several other artists, Hughes and Morris among them, decorated the Union at Oxford with scenes from their beloved Malory. Rossetti was also introduced by Burne-Jones to the poet Algernon Charles Swinburne, who was then at Balliol College.

The American Exhibition

In 1857 Rossetti was commissioned by an ambitious American named Augustus A. Ruxton to organize an exhibition of English paintings for the United States. While the exhibition was drawn from the mainstream of British art, it was the Pre-Raphaelite paintings that created the most excitement. Among the submissions were Madox Brown's masterly, Giotto-esque picture, *Jesus Washing Peter's Feet;* a replica of Hunt's *Light of the World;* Hughes' *Ophelia* and *Home from the Sea: A Mother's Grave;* as well as Siddal's offering, *Clerk Saunders.*

There were complaints: some of the Americans said they had been fobbed off with second-rate representatives of the famous movement. They clamored to see the paintings of the renowned Millais (who went unrepresented because his patrons would not part with his pic-

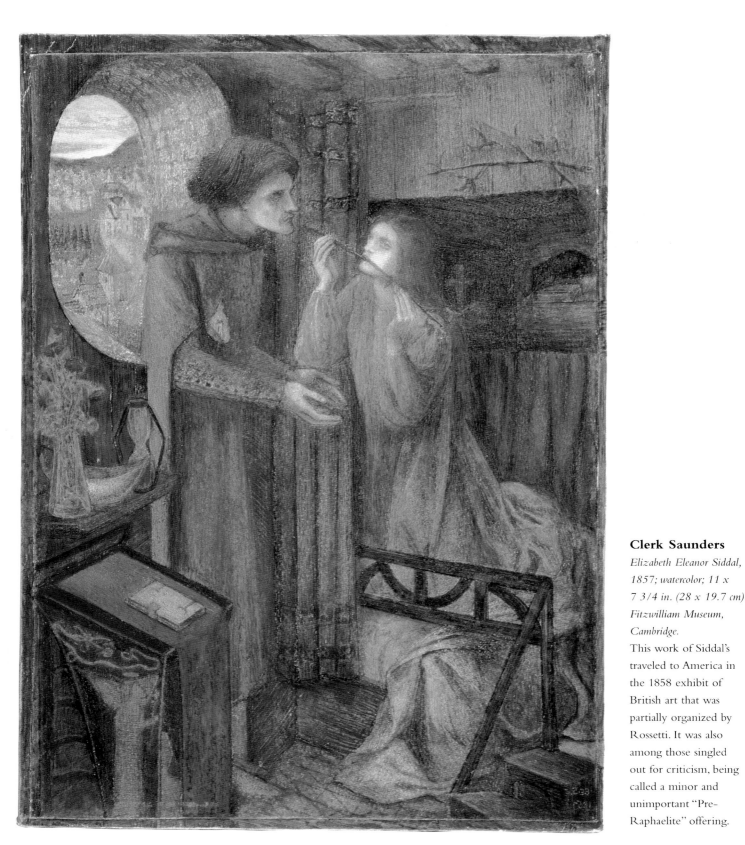

Clerk Saunders

Elizabeth Eleanor Siddal, 1857; watercolor; 11 x 7 3/4 in. (28 x 19.7 cm). Fitzwilliam Museum, Cambridge.

This work of Siddal's traveled to America in the 1858 exhibit of British art that was partially organized by Rossetti. It was also among those singled out for criticism, being called a minor and unimportant "Pre-Raphaelite" offering.

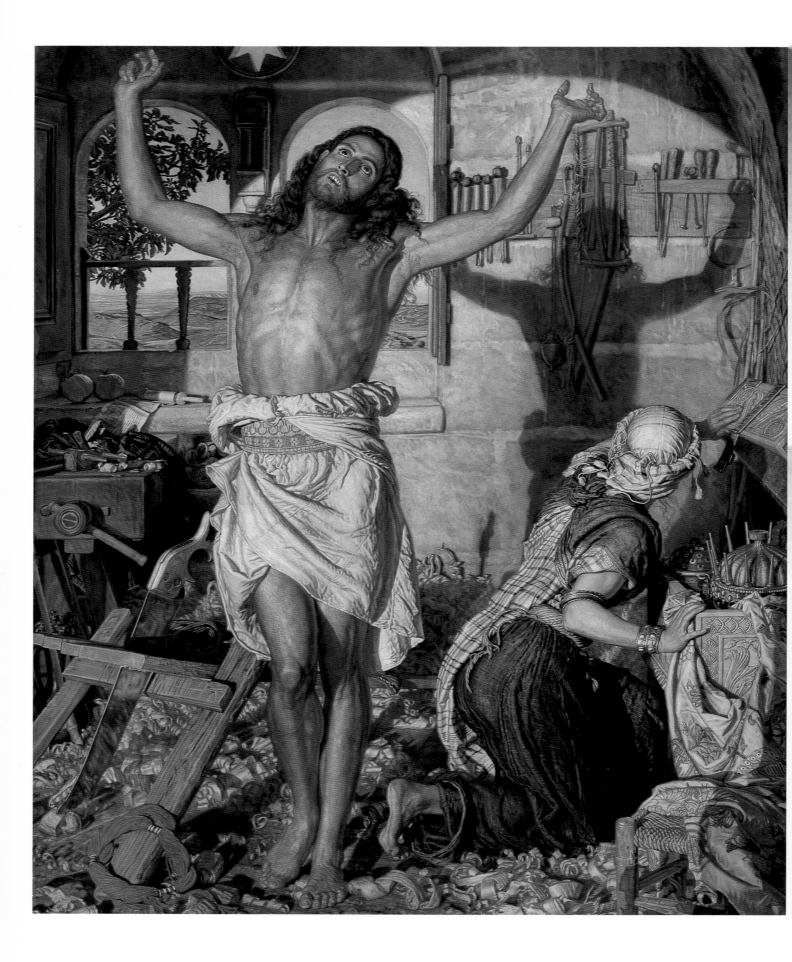

tures). Rossetti's work was also missing. This may have caused unwarranted consternation with those that were present; and some artists—Siddal and Madox Brown among them—were singled out for opprobrium.

The year of 1857 also marked a complete parting of ways between Holman Hunt and Rossetti. Rossetti, with the irresponsibility that had of late become typical of him, had more than flirted with Annie Miller. Miller had told Holman Hunt of it, and boasted of Rossetti's knowledge of where cheap abortions could be had. This disgusted Holman Hunt, who had long grown less sympathetic of Rossetti and was no doubt happy to see the end of him.

Aside from Holman Hunt, Rossetti's flirtations could not have had a salubrious effect on Siddal, who, in addition to her well-known jealousy, would now be reeling from professional rejection. In 1857, too, Rossetti met Fanny Cornforth—with whom he shortly began an affair—and Jane Burden, whose features the painter would first revise into the Pre-Raphaelite mold and then fall in love with.

More happily for Holman Hunt, Woolner now returned from his four-year sojourn in Australia. Although he seemed not to have struck it rich as a gold prospector, his fortunes in England were increasing, for that year he was able to exhibit his sculpture, *Lord Tennyson*. (Woolner would become increasingly well-to-do; and he continued to present his commissions as late as 1882, with his *Memorial to Sir Edward Landseer*. He would never, however, have the influence that the first three painters of the Brotherhood—as well as other latecomers—enjoyed.)

Millais exhibited two pictures in 1857, *A Dream of the Past: Sir Isumbras at the Ford* and *The Escape of a Heretic, 1559*. He found himself temporarily out of the good graces of Ruskin, who declared *Sir Isumbras* "a catastrophe" of a painting.

That, however, would change. The year before, Millais had painted one of his most famous pic-

Alfred, Lord Tennyson

Thomas Woolner, 1857;
bronze medallion.
Usher Gallery, London.
Sculptor Thomas Woolner
continued to present his
commissions as late as
1882, yet he would never
have the influence that the
first three painters of the
Brotherhood enjoyed.

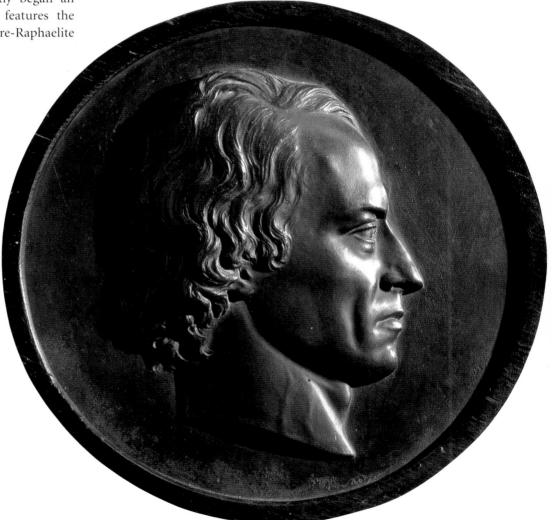

The Shadow of Death

William Holman Hunt,
1870–73; oil on canvas;
83 1/2 x 66 in. (212 x
167.6 cm). Manchester City
Art Gallery, Manchester.
Hunt continued to paint
religious subjects throughout
his life. His convictions,
while seemingly contradictory
at times, were nonetheless
deep; his final break with
Rossetti came from an
unendurable moral affront.

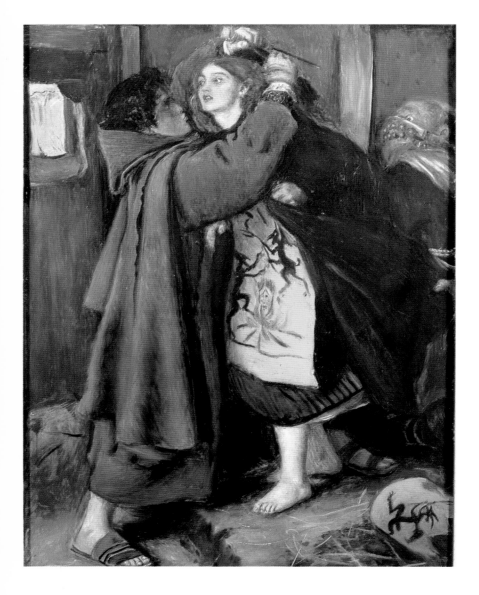

advance in influence and in value, you will be acknowledged to have borne a witness all the more noble and useful, because it seemed to end in discomfiture; though it will *not* end in discomfiture." Ruskin ended his letter to the *Liverpool Albion* with this ringing endorsement: "Since Turner's death I consider that any average work from the hand of the four leaders of Pre-Raphaelitism (Rossetti, Millais, Holman Hunt, John Lewis) is, singly, worth at least *three* of any other pictures whatever by living artists."

In 1858 Morris published his poem, "The Defense of Guinevere," in which that beautiful but feckless queen confirms her adultery while in the act of denying it. Little did Morris know that, within a decade, he would be living his own version of the legend with Rossetti and Jane Burden. Rossetti, in the meantime, had begun his commission of *The Seed of David* for the Llandaff Cathedral in 1858 (completed in 1864), for which he employed Morris as one of his models.

In 1859 Burne-Jones drew a pen-and-ink sketch which he called *Going into Battle*. Its setting is medieval, with tranquil maidens placed against a background of spear-wielding men and a fairy castle. This dreamlike idyll proves an eloquent counterpoint to Hughes' last great picture, *The Long Engagement* (1859). In the course of years, a Shakespearean subject had yielded to a impoverished country parson and his long-suffering fiancée. The painting depicted the misery of the decorous Victorian engagement, which could last up to ten years or more until familial demands of financial security were satisfied. Hughes satisfied the usual demands of Pre-Raphaelite martyrdom by painting the picture in the open air, and in all types of weather.

Perhaps the effort exhausted him. Hughes had retired from London a year before to a quiet sub-

Escape of a Heretic, 1559

Sir John Everett Millais, 1857; oil on panel; 10 x 8 in. (25.4 x 20.3 cm). Forbes Magazine Collection, London.

A winsome young heretic, still wearing the symbol of the *auto-da-fé*, is helped to escape. This painting demonstrated Millais' later, looser style.

tures, *The Blind Girl*. True to Pre-Raphaelite aesthetic, he had set up his easel outside at Winchelsea to observe and record nature. The result was a remarkable burst of colored sky, rendered poignant by the unsighted figure in the foreground. *The Blind Girl* was exhibited at the Liverpool Academy in 1858, with its artist taking grand prize. In spite of its approachable subject matter, a contretemps arose over giving the award to Millais, since a more formal picture by A. Solomon had also captured attention.

In regard to the ensuing fracas Ruskin replied, "Let the Academy be broken up on the quarrel; let the Liverpool people buy whatever rubbish they have a mind to; and when they see, as in time they will, that it *is* rubbish, and find, as they will find, every pre-Raphaelite picture gradually

The Blind Girl

Sir John Everett Millais, 1856; oil on canvas; 32 1/2 x 24 1/2 in. (82.5 x 62.2 cm). City Museum and Art Gallery, Birmingham.
This magnificent painting combines Millais' painterly genius, his faltering Pre-Raphaelite ideals, and his predilection for sentimental subjects into a transcendental experience. Even so, its Pre-Raphaelite elements caused a controversy.

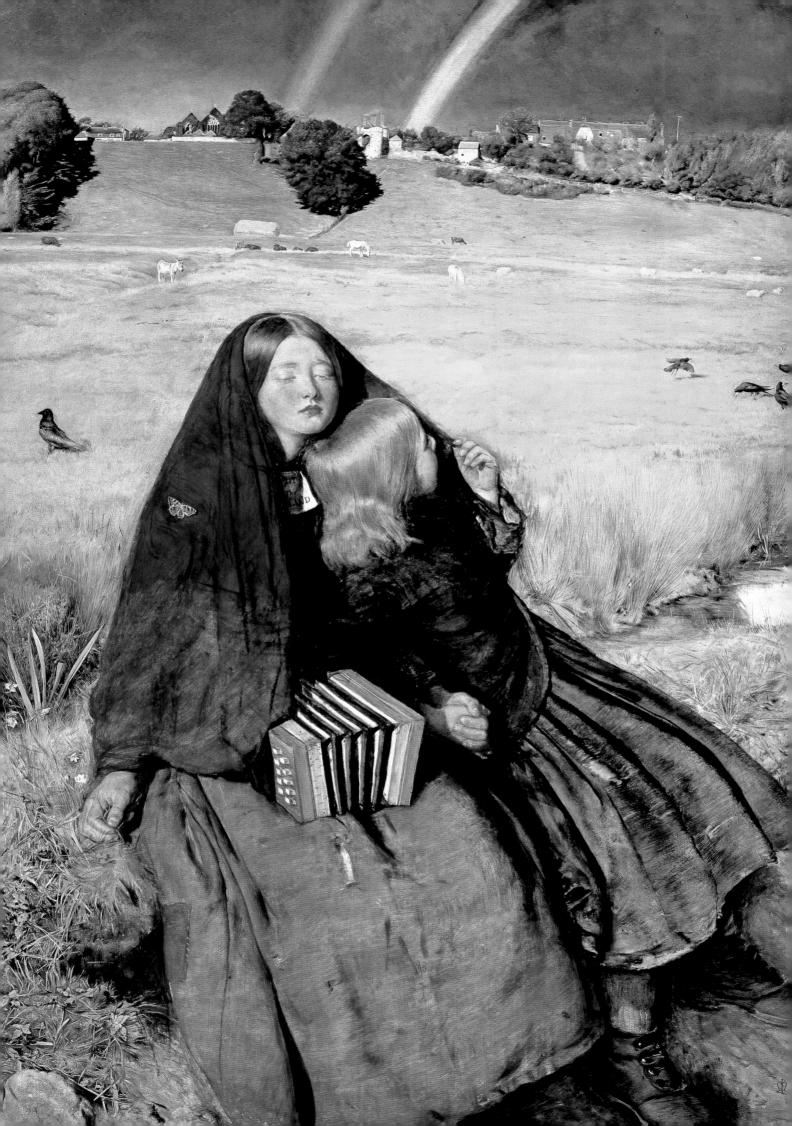

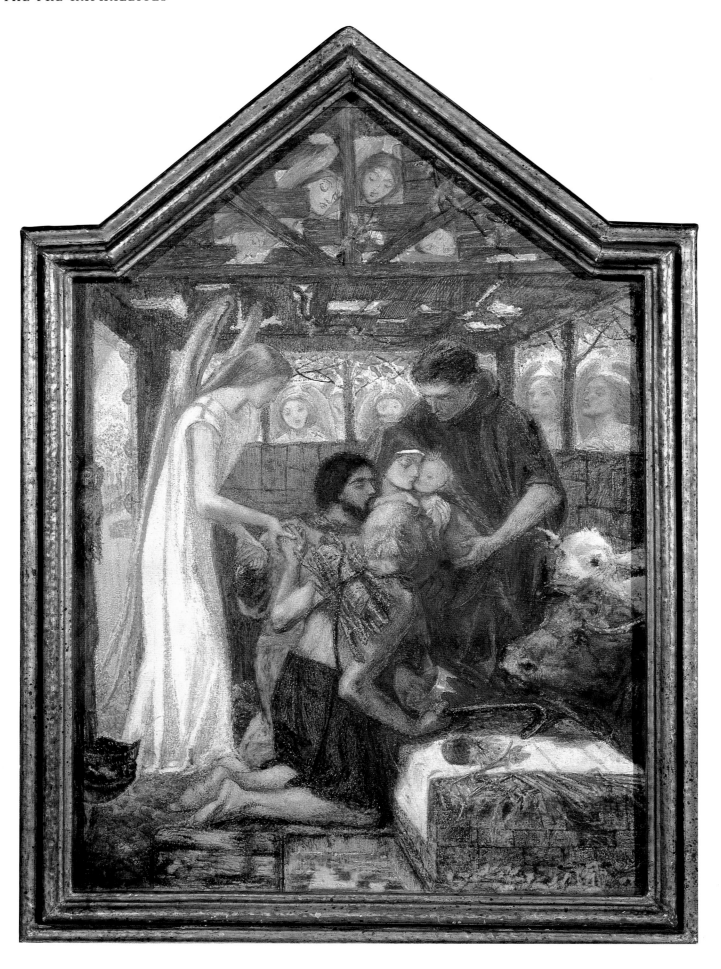

urb; and though he continued to paint and exhibit for many years afterward, he had by then effectively withdrawn from the Pre-Raphaelite milieu.

The Course of Love

There also began, in 1859, a spate of marriages among the Pre-Raphaelites. First, Morris married Jane Burden; then, in 1860, Burne-Jones married Georgiana MacDonald, the young daughter of a nonconformist minister; and Rossetti finally married Elizabeth Siddal. None of these marriages would be a happy one—in fact, Rossetti's would soon turn tragic. The course of Pre-Raphaelite romance seldom ran smoothly. Though the men and women were united by their dedication (in one form or another) to art, they found themselves in other ways to be incompatible.

The women who worked as models generally came from a more lowly class background than the artists did. Elizabeth Siddal's father was a shop clerk; Jane Burden's father was a stable-keeper; and Annie Miller's was an ex-soldier and jack-of-all-trades who had had his daughters brought up in a midden. Though all the women were "stunners" (in the parlance of the time), their other talents or lack thereof spanned a wide spectrum. While Siddal was reserved and, under the tutelage of Rossetti and Ruskin, composed verse and painted in oils, Miller—even after years of Holman Hunt's paid-for lessons in ladyship—was not only quite flagrantly bawdy but almost

The Seed of David

Dante Gabriel Rossetti, 1858–64; oil on wood; 90 x 60 in. (228.6 x 152.5 cm.) center; 73 x 24 1/2 in. (185.4 x 62.2 cm.) wings. Llandaff Cathedral, Wales. The "seed of David" is the young Christ at center. In this triptych Rossetti used both of his mistresses—Jane Burden and Fanny Cornforth— as well as their cuckolded husbands.

illiterate. These women must have known that their allure was primarily that of ornament, and it could hardly have made them feel secure in a world where class distinctions reigned.

Nor did the situation improve when model/helpmeets were chosen from a more acceptable background, as were Georgiana Burne-Jones and Fanny Hunt. The Pre-Raphaelites were sensualists, who, as artists and appreciators of beauty, considered themselves entitled to have affairs. The only relatively happy and normal marriage was that of John and Effie Millais—though she, after all, had begun as Mrs. John Ruskin.

So it was that Rossetti's relationship with Elizabeth Siddal suffered much through his dalliance with Fanny Cornforth. And Burne-Jones' complicated love life occasionally descended into *comedia dell' arte*—such as the time he found his supposedly secret mistress Maria Zambaco chatting away with his wife. Thus it seemed no surprise that, upon the death of Siddal, Jane Morris and Rossetti grew unreasonably close. Even the proper Mrs. Burne-Jones and William Morris, in the absence of their respective mates' affection, were rumored to have grown in their regard for one another.

Upon his marriage Morris and his bride had moved from London to Upton, Kent, where he began the course upon which he was to stay for the rest of his life. With more practicality than most, Morris set out to recreate the medieval world. First, he set about the design of his own furniture and interiors—with some help from his friends. The house itself had been designed in a Gothic style by Morris' friend (and soon-to-be business associate) Philip Webb. It was a little jewel of a house for which Burne-Jones was called upon to supply designs for its lovely stained-glass windows, and Morris himself designed the wallpaper.

Following page:
A Dream of the Past: Sir Isumbras at the Ford
Sir John Everett Millais, 1857; oil on canvas; 49 x 67 in. (124.5 x 170.2 cm). Lady Lever Gallery, Port Sunlight. Ruskin, a staunch defender of Millais, referred to this painting as a "catastrophe." Many wondered if the great Ruskin's criticism was provoked by the loss of his wife Euphemia ("Effie"), who had fallen in love with Millais.

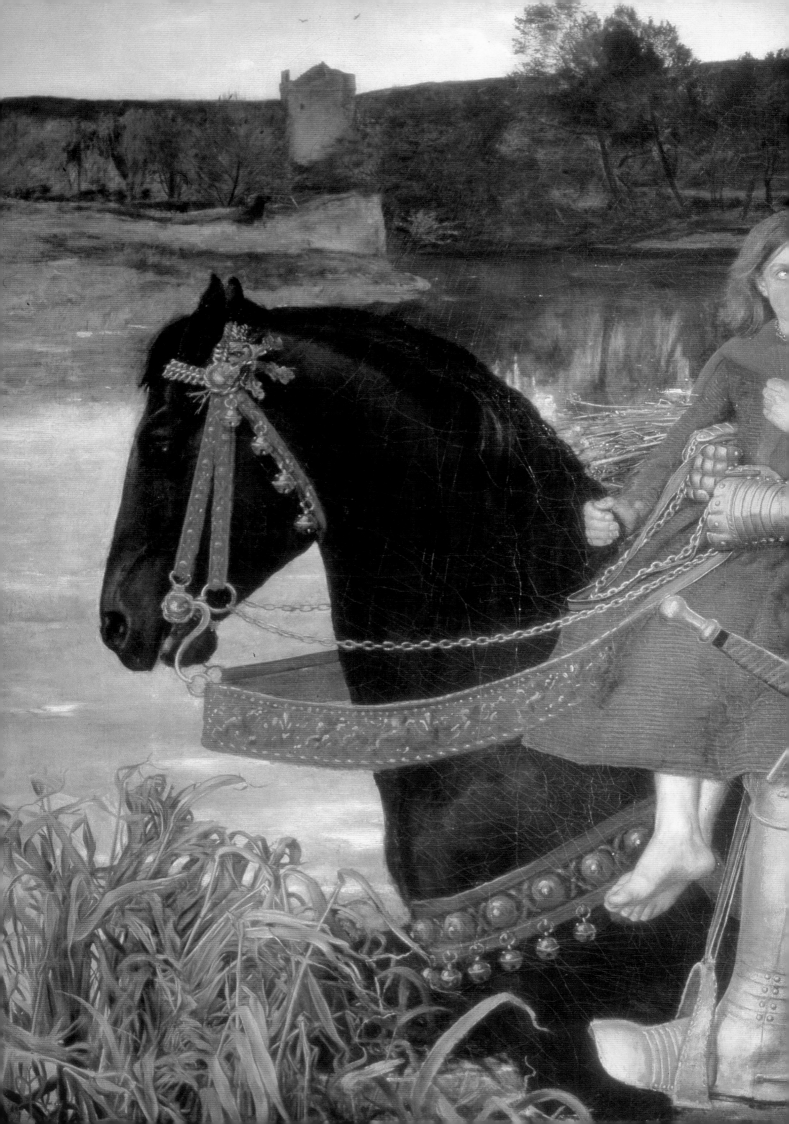

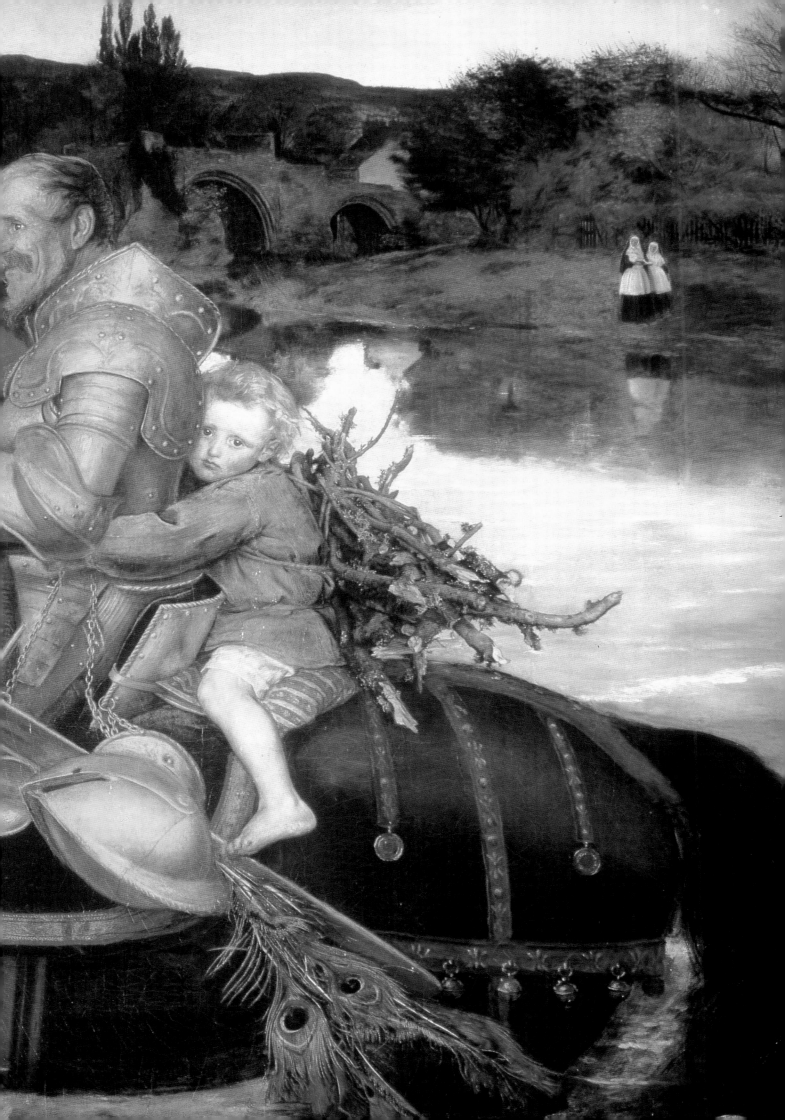

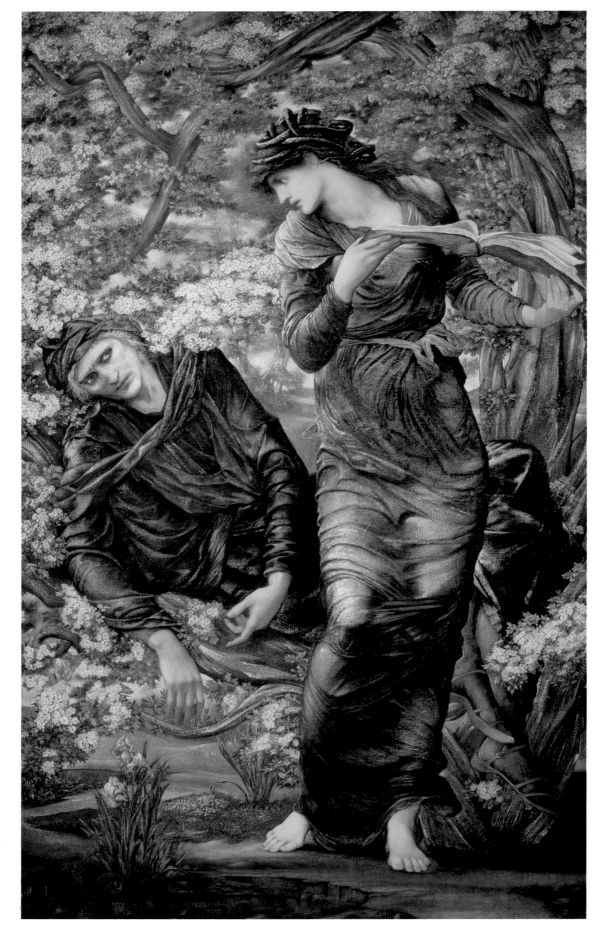

The Beguiling of Merlin

Sir Edward Coley Burne-Jones, 1873–77; oil on canvas; 73 x 43 3/4 in. (185.4 x 111.1 cm). Lady Lever Art Gallery, Port Sunlight. Eight years after painting *Merlin and Nimue,* Burne-Jones revisited Merlin, trapped and helpless in Nimue's spell. The flowering trees that are almost smothering him reflect the ascendance of fertility—another source of feminine power and possible male entrapment.

Birth of the Aesthetic

Although they each continued to work for the rest of their long lives, it was clear that the wand had passed from the first artists of Pre-Raphaelitism to their spiritual descendants. In a way, it did not appear to matter much to them: they had become famous and were justly lionized. As William Angus Knight, an associate of Ruskin's and a lecturer in art, put it, "Rossetti, Woolner, Madox Brown, Millais, subsequently left it [Pre-Raphaelitism], on the ground that, having assimilated its best, they had outgrown it, and were able to go on to other things; some more slowly, others more swiftly; but it remained to all of them a landmark, as it had been a rallying point to them as youthful enthusiasts and devotees."

Of those so-called devotees, Morris and Burne-Jones assumed the greatest prominence. Morris, Marshall, Faulkner & Co., the first of Morris' interior design companies, was created in 1861, with the assistance of key Pre-Raphaelites like Rossetti. Through it, Morris would impose his remarkable and enduring vision. What that would be was yet to be seen, and yet the pieces were already in place.

With pictures like *Merlin and Nimue* (1861), Burne-Jones too was imposing upon the world his vision, a storybook world of classical chivalry. The revolution in art proposed by the Pre-Raphaelites and propounded by Ruskin was about to give way to a new, more enchantingly decorative age— the dream world incarnated by the Aesthetics.

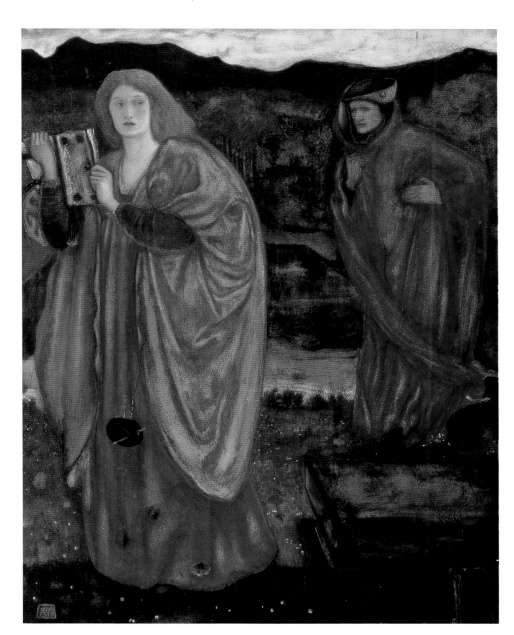

Merlin and Nimue

Sir Edward Coley Burne-Jones, 1861; oil on canvas;
23 1/2 x 45 in. (59.7 x 114.3 cm). Victoria & Albert Museum, London.
In this picture, Nimue seems to be obscuring her actions from the glowering gaze of Merlin, and the master–pupil relationship between the sorcerer and his apprentice seems fraught with hidden drama.

Ariadne
William Morris, 1870;
glazed ceramic tile. Victoria
& Albert Museum, London.
Morris, Marshall, Faulkner & Co.
designed domestic architecture
and interior decoration, such as
furniture, tapestries, wallpaper,
and stained glass. In typical entre-
preneurial style, wives, friends,
and family were all engaged in
the production of the materials.

The Beguiling of Merlin
detail; Sir Edward Coley Burne-Jones,
1873–77; oil on canvas. Lady Lever
Art Gallery, Port Sunlight.
An examination of Merlin indicates
how much Burne-Jones is concentrat-
ing on the face and its expression,
while the flowers that surround the
figure are impressionistically rendered.

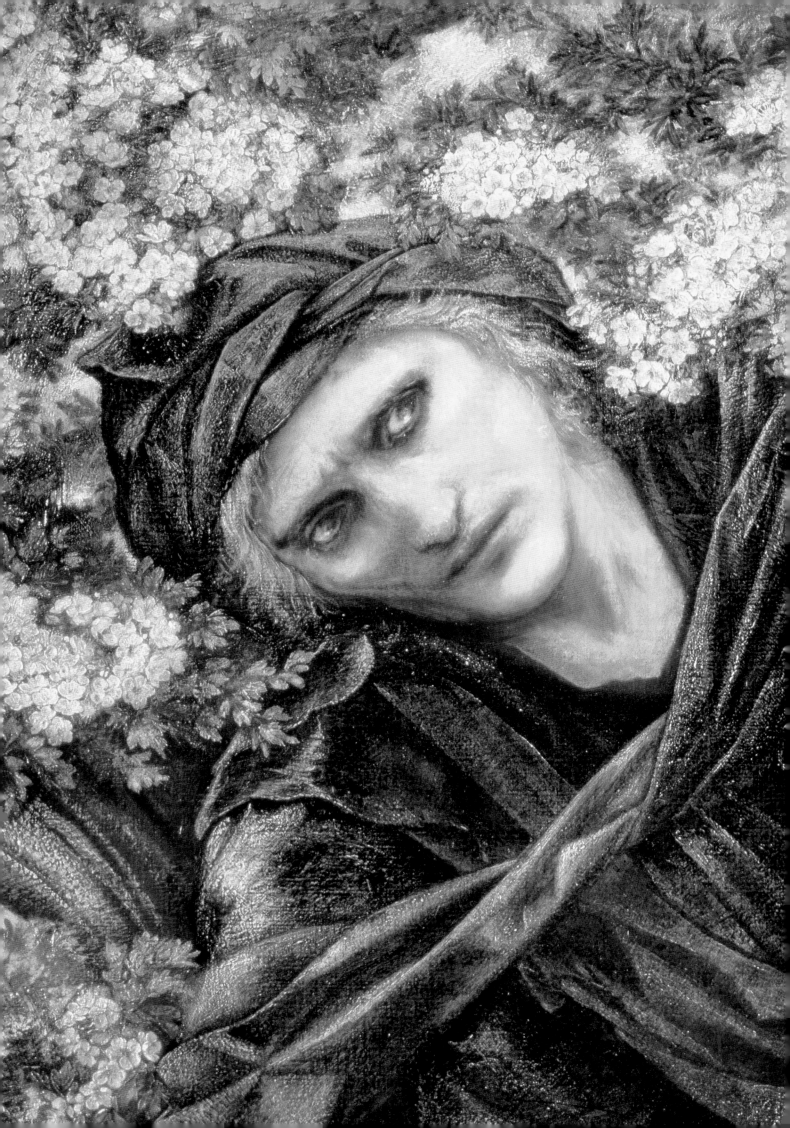

The Glacier at Rosenlaui

John Brett, 1856; oil on canvas; 17 1/2 x 16 1/2 in.
(44.4 x 41.9 cm). The Tate Gallery, London.
Brett was tremendously influenced by Ruskin, who,
among other enthusiasms, held that a sign of artistic
mastery was the execution of glacier and rock formations.

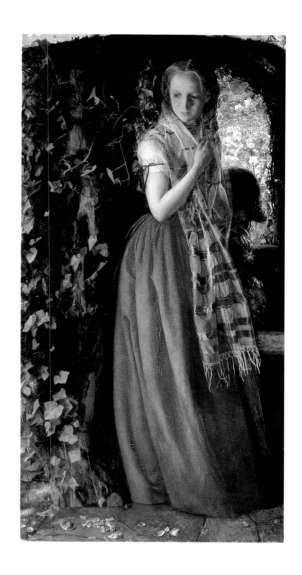

April Love

Arthur Hughes, 1856; oil on canvas; 35 x 19 1/2 in.
(88.9 x 49.5 cm). The Tate Gallery, London.
This richly toned, somber painting was among
Hughes' greatest works. It was purchased by
William Morris while he was still at Oxford.

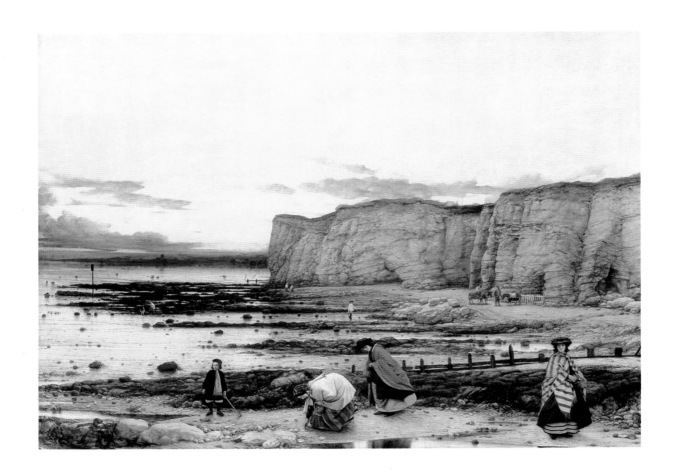

Pegwell Bay, Kent: A Recollection of October 5th, 1858

William Dyce, 1858–60; oil on canvas; 24 3/4 x 35 in.
(62.9 x 88.9 cm). The Tate Gallery, London.
Ruskin placed Dyce into the category of false Pre-Raphaelites
who mistook "sharp edges" for realistic detail. Although the work
appears to suffer from this "ailment," it is charming nevertheless.

Virgin and Child with SS. John the Baptist and Nicholas
Raphael, c. 1506; oil on canvas; 81.7 x 58 in.
(209.6 x 148.6 cm). The National Gallery, London.
Here, Raphael groups his nativity between St. John the Baptist, who
foretold of Christ's coming, and St. Nicholas, who came afterward.

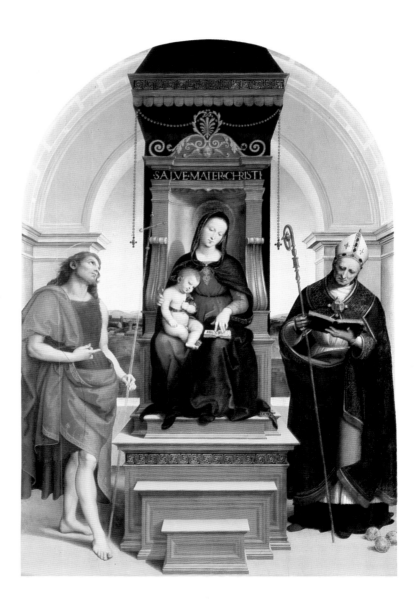

The Seed of David

detail; Dante Gabriel Rossetti, 1858–64; oil on wood. Llandaff Cathedral, Wales.
In the left wing of this famous triptych, the old David, modeled by Morris,
contemplatively strums a lyre. In this unusual placement, he precedes his own youth.

The Seed of David

detail; Dante Gabriel Rossetti, 1858–64; oil on wood. Llandaff Cathedral, Wales.
In the right panel of the triptych is seen the young David. He holds his
famous sling, but has nothing yet of the riches—and tragedy—to come.

Sancta Lilias
Dante Gabriel Rossetti, 1874; oil on canvas;
19 x 18 in. (48.3 x 45.7 cm). The Tate Gallery, London.
This portrait of idealized beauty is typical
of Rossetti's work after the death of Siddal.

Lady Affixing Pennant to a Knight's Spear

Elizabeth Eleanor Siddal, c.1861; watercolor. The Tate Gallery, London.
Rossetti's mistress Elizabeth Siddal, with the encourage-
ment of her lover as well as Ruskin, also took up pen
and brush. She was encouraged in her creative endeavors
by Ruskin, who felt she had extraordinary talent.

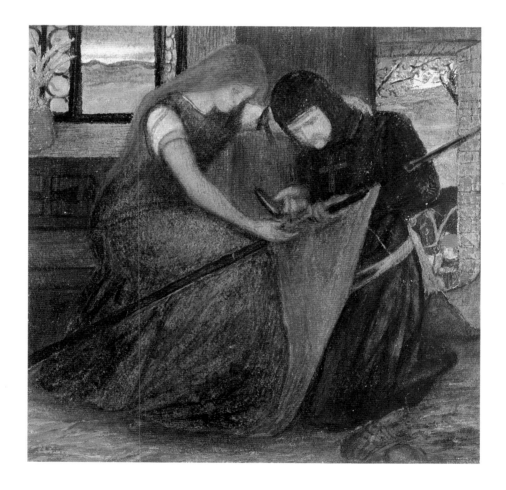

The Woodman's Child

Arthur Hughes, 1960, oil on canvas; 23 3/4 x 25 in.
(61.0 x 64.1 cm). The Tate Gallery, London.
Many were the biting insects, pouring rainstorms, and other
bucolic miseries encountered by the Pre-Raphaelite artists
while conforming to the precept of painting in natural light.

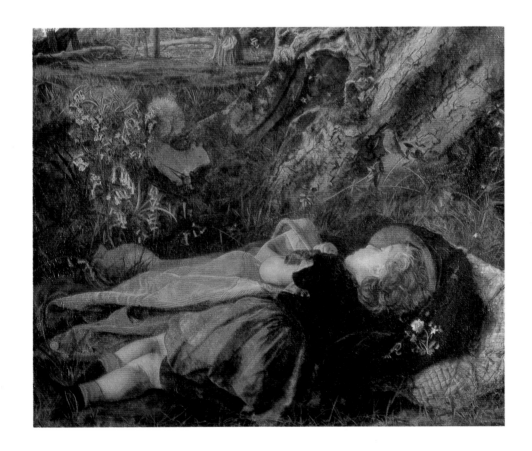

**Aurora Leigh's Dismissal
of Romney ("The Tryst")**
*Arthur Hughes, 1860; oil on canvas;
15 1/4 x 11 3/4 in. (38.7 x 29.8 cm).
The Tate Gallery, London.*
Hughes was disdained by some for
having a broad sentimental streak. Still,
he believed in the Pre-Raphaelite ideals
and strived to follow them in his work.

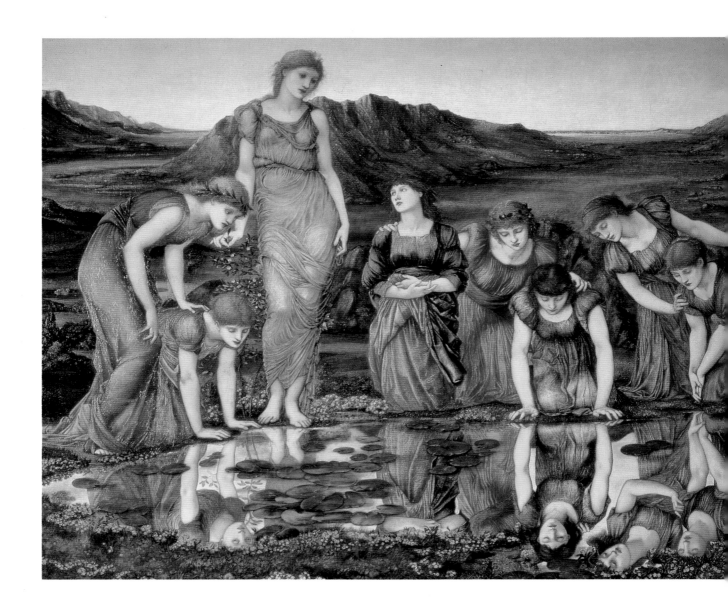

The Mirror of Venus

Sir Edward Coley Burne-Jones, 1877 (1898); oil on canvas; 47 1/4 x
78 3/4 in. (120 x 200 cm). Calouste Gulbenkian Foundation, Lisbon.
In this picture, a bevy of beauties enjoy their reflection in a
clear pool. While less saccharine than Millais, Burne-Jones'
paintings drew an appreciative coterie of collectors.

Guinevere

William Morris, 1858; oil on canvas; 28 1/4 x 19 3/4 in. (71.7 x 50.1 cm). The Tate Gallery, London.
Morris' draftsmanship was exceptional; both he and Burne-Jones were confirmed doodlers, and so were able to hone their already great talents.

HAST thou longed through weary days
For the sight of one loved face,
Hast thou cried aloud for rest,
Mid the pain of sundering hours,
Cried aloud for sleep and death
Since the sweet unhoped for best
Was a shadow and a breath —
O, long now, for no fear lowers
O'er these faint feet-kissing flowers
O, rest now; and yet in sleep
All thy longing shalt thou keep.

Thou shalt rest, and have no fear
Of a dull awaking near,
Of a life for ever blind,
Uncontent and waste and wide.
Thou shalt wake, and think it sweet
That thy love is near and kind
Sweeter still for lips to meet;
Sweetest, that thine heart doth hide
Longing all unsatisfied
With all longing's answering
Howsoever close ye cling

"Love Fulfilled" from *A Book of Verse*
William Morris, 1870; book illustration. Victoria & Albert Museum, London. Morris was himself a Renaissance man, writing with what Swinburne called a "slow, spontaneous style" and embroidering his words— sometimes literally— within delightful designs.

Peach Wallpaper
William Morris, 1866; print. Victoria & Albert Museum, London. To offer more to the less well-off, Morris embarked on a series of relatively inexpensive wallpapers, which soon became all the rage.

"Wandle" Chintz

William Morris, 1884; textile. Victoria & Albert Museum, London.
This Morris textile was named after the Wandle River. Morris revolutionized the design and execution of textiles through his companies Morris, Marshall, Faulkner & Co. and later, Morris & Co.

1862-1910: MORRIS & CO.

Morris, Marshall, Faulkner & Co. began oper ating in 1861 with the simple intention of providing beautiful interiors in the Pre-Raphaelite manner, which Morris and Burne-Jones had already adapted to their own "medieval" aesthetic. For this purpose Morris enlisted the help of not only Burne-Jones but Rossetti, Webb, and Madox Brown as well as Charles Faulkner and Peter Paul Marshall. The firm designed domestic architecture and interior decoration, such as furniture, tapes-tries, wallpaper, and stained glass. In typical entre-preneurial style, all interested parties, such as wives, friends, and family, were engaged in the production of the materials.

The firm, idealistically begun, gained notice at the International Exhibition of 1862 and became some-what fashionable with an artistic crowd, for whom "Pre-Raphaelite" furnishings had a definite attrac-tion. In all things having to do with the business, Morris' was the guiding hand, including and espe-cially his evolving philosophy of Arts and Crafts.

**Morris Room,
Green Dining Room**

William Morris, 1866. Victoria & Albert Museum, London. The green dining room was the paradigm for all Morris design, the synthesis of a total decor.

The Death of Ophelia

In 1862, less than two years after she married Rossetti, Elizabeth Siddal killed herself with an overdose of laudanum. Although it was not proved to be a suicide, Siddal had been plagued for years both by mysterious illnesses and by Rossetti's infidelities. More recently, a miscarriage had shaken her and increased her dependency on the narcotic. These factors may have contributed to the troubled judgment that resulted in her taking of the fatal dose.

Rossetti blamed himself, with some justification. He mourned his wife dramatically, burying along with her the only manuscript of a selection of his poems. Presumably it was, at the time, to have been his deathless statement on the death of art. In his immediate private life, however, Fanny Cornforth was as yet his paramour, coming and going in the midst of his grief. There was also Jane Morris to console him. Jane would become increasingly important to Rossetti as both muse and lover in the coming years, to the consternation, naturally, of Morris himself.

Rossetti moved to a new home at 16 Cheyne Walk, which was also known as The Queen's House, for Catherine of Braganza was said to have lived there. Rossetti's own housemates included the poets George Meredith—who would publish his volume of sonnets, *Modern Love*, that year—and Swinburne. Of the three, it was Swinburne's star that would rise meteorically within a few years; and he, in his turn, would prove to be a true friend to Rossetti, upholding his career whenever possible.

Swinburne had keen admiration for the poems of Rossetti's sister, Christina. In 1862, Christina Rossetti published *Goblin Market and Other Poems*, the achievement for which she is known to this day. In the curious title poem, two sisters, Lizzie and Laura, are beset by goblins, who beseech the girls to taste their fruit. Laura is tempted to try it, and is immediately struck with a wasting disease. In desperation, Lizzie begs the

goblins to give her their fruit so that her sister may live. In a rage that Lizzie will not taste the fruit herself, the goblins smash it against her and she is covered with sweet pulp. This Lizzie takes to her sister, whom she entreats to "taste" her. The narrative ends with Laura recoiling at the taste of goblin juice on Lizzie's skin; the yearning for forbidden fruit is withdrawn, and Laura's health improves.

The poem speaks of various and commonplace Victorian themes, such as the consequences for women who fall to temptation, which can only be read as seduction and abandonment. Still, there is the disquieting testimony of sister Laura, while still in the throes of sensual passion:

> You cannot think what figs
> My teeth have met in,
> What melons icy-cold
> Piled on a dish of gold
> Too huge for me to hold . . .

In their subtle and subversive way, the chords that "Goblin Market" struck were as erotically moving as any by the leading male poets of the day. From there, however, the poem twists away again, into the proper feminine theme of devotion to family:

> For there is no friend like a sister,
> In calm or stormy weather;
> To cheer one on the tedious way,
> To fetch one if one goes astray . . .

An altogether "jolly" tone, as if one is being determinedly directed away from other thoughts entirely, ideas that are best left unexpressed.

This edition of *Goblin Market* contained four engravings by Rossetti; the primary illustration was that of the two sisters, depicted in a somewhat robust Pre-Raphaelite mold, locked in each other's arms.

Additionally in 1862 Millais exhibited *The Music Mistress*. The painting represented a gentlewoman working for pay, and the model was his wife, Effie. In fact, Millais had ceased to employ the tempestuous beauties who had inspired earlier paintings by the Pre-Raphaelites. Now, he boasted of Effie's ability to procure for him models of every type (except, apparently, sensuous) for a pittance. Perhaps Millais did not realize that his work had been veering for years toward the same, prosaic quality that the young

Panel from the Briar Rose: Sleeping Beauty

Sir Edward Coley Burne-Jones, 1871–90; oil on canvas; 28 1/2 x 50 1/2 (72.4 x 182.3 cm). Faringdon Collection, Buscot Park, Faringdon. Burne-Jones' world was often dark and murky, as the Briar Rose Series indicates. Nothing could be farther to the Pre-Raphaelite tenets of bright color and detail; yet Burne-Jones, under the wing and influence of Rossetti, was considered one of them.

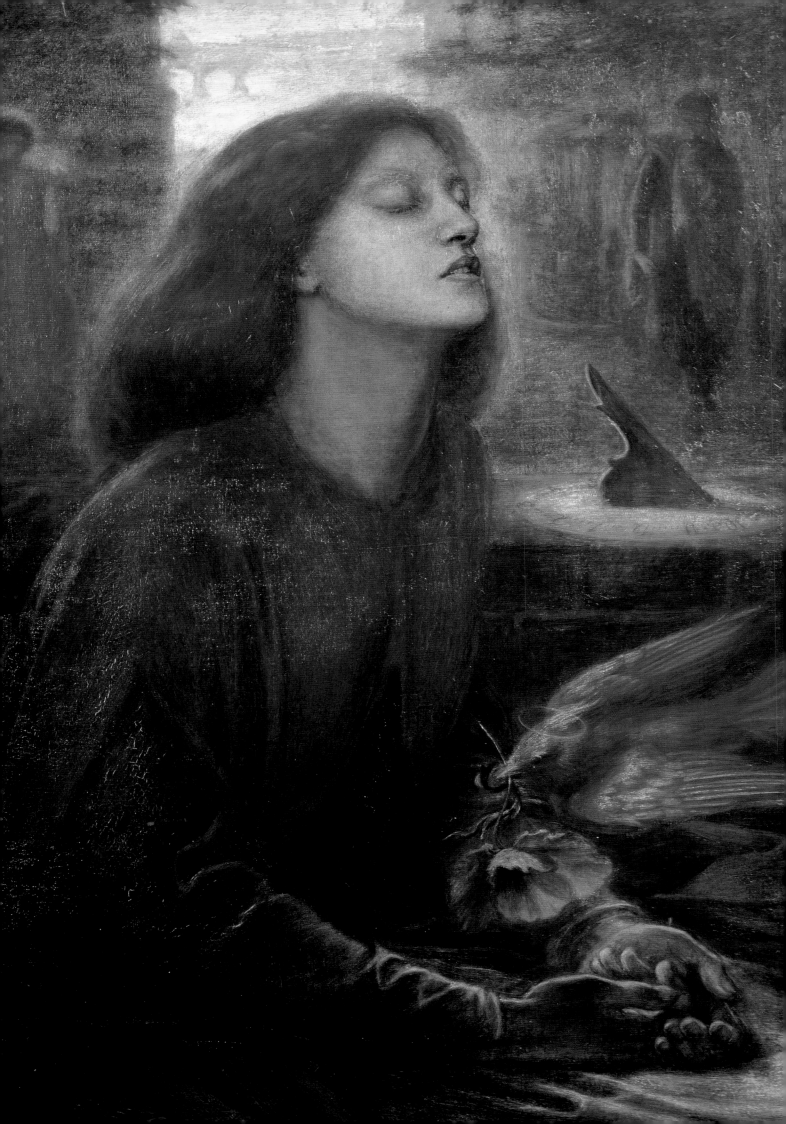

artist had found so objectionable in his elders; or else, of course, he did not care.

While the principals of the movement had gone their separate ways, Pre-Raphaelitism was still the prevailing aesthetic. Among those who had come under the Pre-Raphaelite spell was a middle-aged woman named Julia Margaret Cameron. Mrs. Cameron (the aunt of future author Virginia Woolf), returning from a trip to India with her civil-servant husband, had taken to photography. She delighted in having illustrious guests—Charles Darwin and Thomas Carlyle among them—dress up in costume and sit for her. Of her portraits—done up deliberately in the Pre-Raphaelite manner—those of actress Ellen Terry and Alfred Tennyson (in a costume which he called "the dirty monk") are among the best known.

In 1863 Burne-Jones' paintings included *Wine of Circe* and *The Annunciation (The Flower of God)*. Rossetti completed a posthumous homage to Siddal, *Beata Beatrix*, sometime around this time. It provided an interesting contrast to Millais' much more socially acceptable picture of that year, *My First Sermon*. In fact, the sun of societal approval continued to shine on Millais, for in 1864 he became a full member of the Academy.

Holman Hunt had finally shaken off Miller's impecunious demands (she had given up on marriage, and had briefly settled on blackmail). With that unfortunate relationship behind him, he married Fanny Waugh in 1865. Symbolically perhaps, he painted Fanny's face where Miller's would have gone had she continued to sit for *Il Dolce Far Niente* (1866). It was a bold move, since Fanny's strong, dark features contrasted disturbingly with what remained of Miller's fair coloring. Afterward, he painted a more truthful portrait—finished posthumously, it seems, for the marriage ended tragically the following year, with Fanny's death in childbirth. So long a bachelor, Holman Hunt was once again alone. He did, however, remain close to the Waugh family, with the result that he married Fanny's sister, in 1875.

My First Sermon

after Millais, c. 1863; mezzotint print; 25 1/4 x 18 1/4 in (64.2 x 46.3 cm). Victoria & Albert Museum, London.
Before photography began to be commonly used, engraving was the method by which art was popularized. Engravings of Millais's works were rather unusual, as his collectors would not often part, even temporarily, with their treasures.

Beata Beatrix

Dante Gabriel Rossetti, 1864–70; oil on canvas; 34 x 26 in. (86.4 x 66 cm). The Tate Gallery, London.
This painting is Rossetti's artistic homage to his late wife, Elizabeth Siddal. Rossetti was obsessed with his namesake throughout his life; likening Siddal to Dante's love could be no greater praise for her.

The Second Generation

Meanwhile, in 1865, Swinburne, Rossetti's erstwhile housemate, had burst on the literary scene with his poem "Atalanta in Calydon." The poem drew from classical sources upon the legend of the virgin huntress Atalanta, through whom the royal family of Calydon is destroyed. It is presented in the form of a tragedy, the message of which was the danger of women mixing in a man's world. Swinburne's poetry was considered extravagant and erotic; he would soon enough be criticized for the "fleshliness" that was simultaneously repugnant and attractive to the Victorians.

In defiance, perhaps, Rossetti was also becoming more openly fleshly in his creative pursuits. Although he continued to paint after Siddal's death, he had begun to concentrate on single, voluptuous female figures, such as *Monna Vanna* (1866). These were as determinedly wanton to the Victorian public as Millais' subjects were respectable.

During this time, Burne-Jones saw his fortunes rise. He moved to a series of better homes—first to Kensington Square in 1865. In 1866, he experienced one of his deep depressions, which concerned Ruskin so much that he hired, for the sum of £200, a known rascal named Howell to act as jester to his moribund friend. Howell played Puck around the gloomy Burne-Jones, who did, in fact, cheer up, and painted one of his most famous works, *Cupid Delivering Psyche*. His fortunes improved again, and he moved his family to their final home, The Grange, Fulham, in 1867.

Howell continued to amuse Burne-Jones until 1868, when he "invited" Burne-Jones' mistress, Maria Zambaco, to meet Mrs. Burne-Jones. Zambaco—a flamboyant individual who became known to all the artist's friends—had at first entranced Burne-Jones, but later startled

Il Dolce Far Niente

William Holman Hunt, 1866; oil on canvas;
39 x 32.5 in. (99.1 x 82.5 cm).
The Forbes Magazine Collection, New York.
This painting was originally meant to placate the restless Annie Miller with the promise of marital bliss. Instead, the artist married Fanny Waugh and painted her rather strong face in place of Annie's.

him with a number of scenes both public and private. Through it all, Burne-Jones continued to paint (in fact, he seldom stopped). He began a series of pictures called *Pygmalion and the Image* and completed *St. George and the Dragon* that year. He also began a series of illustrations for *The Earthly Paradise*, Morris' pastoral four-volume poem, an edition that was unfortunately never realized.

Many, from contemporary readers to those of the present day, have commented on Morris' slow, sonorous style, as is evidenced at the beginning of *The Earthly Paradise,*

> Of Heaven or Hell I have no power to sing,
> I cannot ease the burden of your fears,
> Or make quick-coming death a little thing,
> Nor for my words shall ye forget your tears,
> Or hope again for aught that I can say,
> The idle singer of an empty day.

Monna Vanna

Dante Gabriel Rossetti,
1866; oil on canvas;
35 x 34 in. (88.9 x 86.4 cm).
The Tate Gallery, London.
The strong character of the model, Alexa Wilding, unexpectedly comes to the fore in this portrait. Originally entitled *Venus Veneta*, the picture shows a delight of ornament suitable for a court sitting.

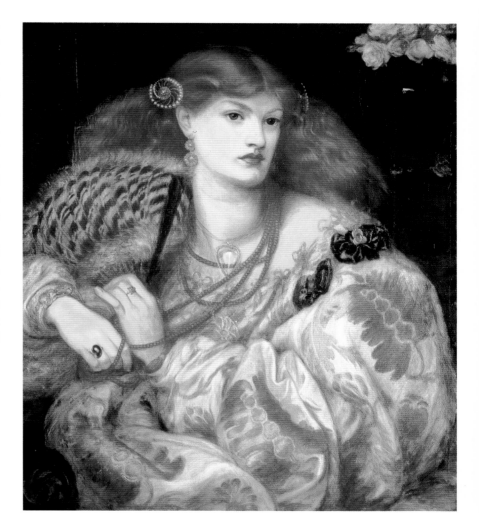

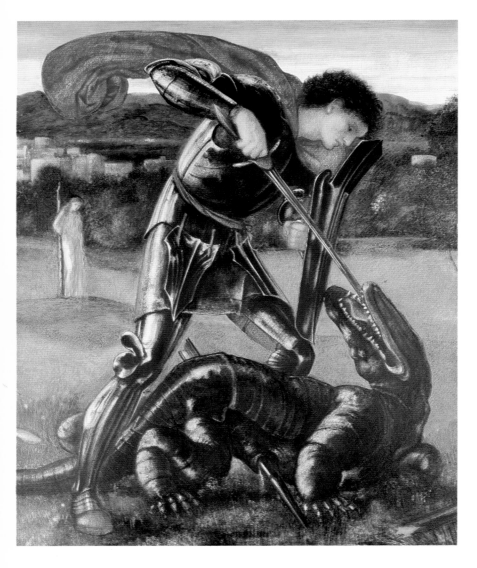

fect as music and colour the sense and spirit of his work."

Late in the artist's career as it was, *Dante's Dream* was a very influential work, and did much to improve Rossetti's flagging reputation. Of this picture, Yeats, in his memoir, *Four Years*, recalled,

> When I was fifteen or sixteen, my father had told me about Rossetti and Blake and given me their poetry to read; & once in Liverpool on my way to Sligo, I had seen "Dante's Dream" in the gallery there—a picture painted when Rossetti had lost his dramatic power, and to-day not very pleasing to me—and its colour, its people, its romantic architecture had blotted all other pictures away.

The next elevation to Rossetti's fame was to come, literally, over Siddal's dead body. From the beginning of his artistic career, Rossetti had composed verse; in fact, Pre-Raphaelite principle required it. However, he determined to take the next step and, in 1869, thus had Siddal exhumed so that he could recover his manuscript of poems, till then buried reverently with her. Having recovered it he revised and published it as *Poems* in 1870. The volume was given glowing notices from Swinburne (among others), but criticism from an unlooked-for source was soon to change the poet's life.

Burne-Jones continued to be amazingly prolific. Among his works for 1870 were the picture *Phyllis and Demophoon*, his own depiction of *Beatrice*, and a painting called *The Sleeping Knights*. The subject of the latter was incorporated into the Briar Wood murals, which he began in 1871, taking nearly twenty years to complete.

Saint George and the Dragon
Sir Edward Coley Burne-Jones, 1868; oil on canvas; 42 x 51 1/2 in. (106.6 x 130.8 cm). William Morris Gallery.
Here, a popular English legend is recounted with a flourish. Like his friend William Morris, Burne-Jones preferred to live in a dream world peopled with knights and ladies, and demons who could be conquered.

Thus forewarned of his narrative intent, many readers have been moved to ask themselves, "Then,—what?" Still, as can be seen, Morris' language had the ability to move, provided one had the patience for it.

Rossetti began, in 1868, his last great work, *Dante's Dream at the Time of the Death of Beatrice* (1869–1871), another hagiography for Siddal and an expression of his lifelong reverence for the great Italian poet. In his Exhibition Notes of 1868, Swinburne praised the unfinished portrait warmly, calling it "perhaps the noblest of Mr. Rossetti's studies after Dante," and declared that "once more it must appear that the painter alone can translate into words as per-

Beatrice
Sir Edward Coley Burne-Jones, 1870; oil on canvas. Private collection.
The feminine ideal of Dante's Beatrice was frequently portrayed by the Pre-Raphaelites. In Burne-Jones' painting, Beatrice is the object of other women's attention, and perhaps envy.

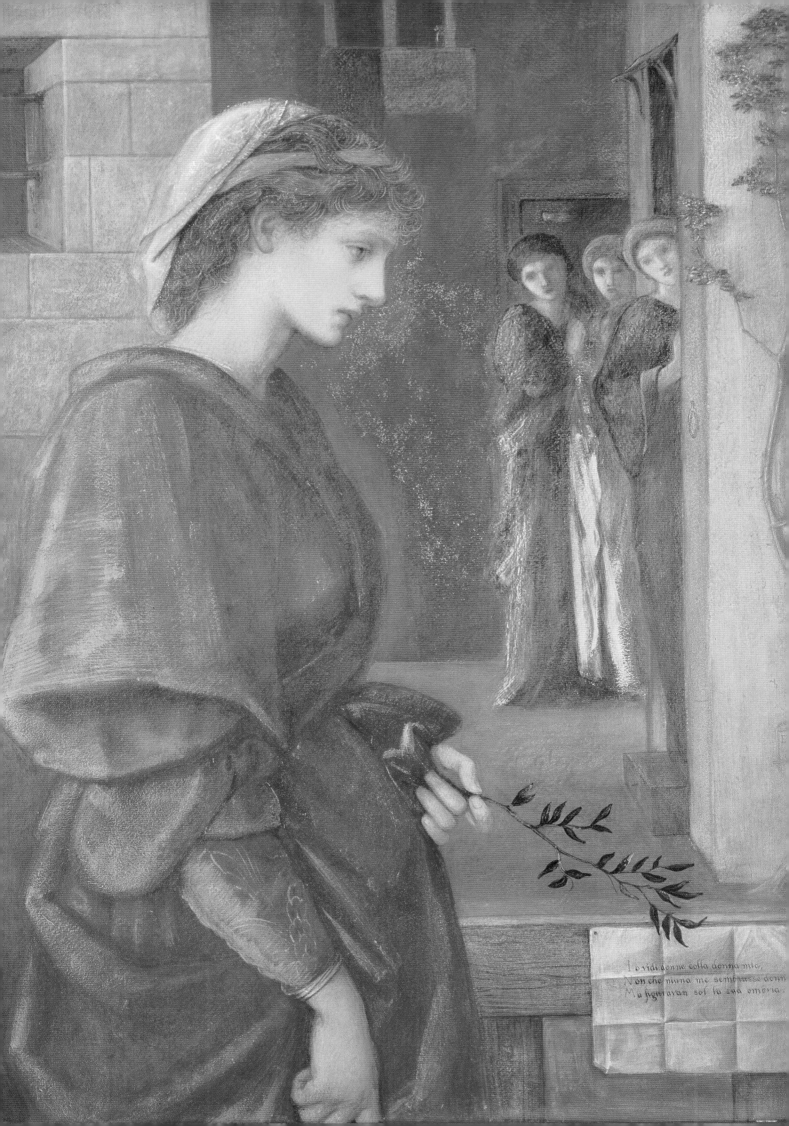

Io vidi donne colla donna mia,
Non che niuna me sembrasse donna,
Ma figuravan sol la sua emprion

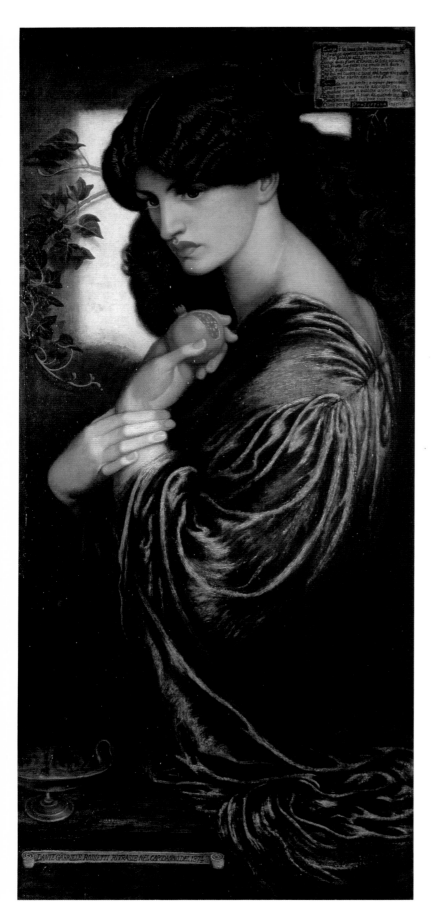

"Nothing Completely Sane"

Rossetti may have been basking in his new-found status as poet, but in 1871 the bottom fell out. Fellow poet Robert Buchanan's essay, *The Fleshly School of Poetry*, dealt him blows from which he would never recover. Writing pseudonymously as Thomas Maitland, Buchanan accused the Pre-Raphaelite's associates of log-rolling in his behalf, and even reserved a backhand for Brother William Michael Rossetti, labeling him "the editor of the worst edition of Shelley which has ever seen the light."

Employing that special venom that poets seem to reserve for one another, Buchanan exposed some of Rossetti's awkward phrasings and questionable metaphors. While claiming that "The Blessed Damozel" had "a few lines of real genius," Buchanan dismissed Rossetti as "a fleshly person, with nothing particular to tell us or teach us, with extreme self-control, a strong sense of colour, and a most affected choice of Latin diction." He called Rossetti superficial in so many words:

> Those qualities that impress the casual spectator of the photographs of his pictures are to be found abundantly among his verses. There is the same thinness and transparence of design, the same combination of the simple and the grotesque, the same morbid deviation from healthy forms of life, the same sense of weary, wasting, yet exquisite sensuality; nothing virile, nothing tender, nothing completely sane; a superfluity of extreme sensibility, of delight in affected forms, hues and tints, and a deep-seated indifference to all agitating forces and agencies, all tumultuous griefs and sorrows, all the thunderous stress of life, and all the storm of speculation . . . the mind of Mr. Rossetti is like a grassy mere, broken only by the dive of some water-bird or the motion of floating insects, and brooded over by an atmosphere of insufferable closeness. . . . Judged relatively to his poetic associates [Morris and Swinburne], Mr. Rossetti must be pronounced inferior to either.

Proserpine

Dante Gabriel Rossetti, 1874; oil on canvas;
49 3/4 x 24 in. (126.4 x 61 cm). The Tate Gallery, London.
A somber Jane Morris posed for this painting.
Here, she is Proserpine, the unwilling wife of a
powerful god. She holds a pomegranate, which indicates
both fertility and the extent of her yearly entombment.

In the fascinating description of Rossetti as "a grassy mere," Buchanan employs some of the images that are present in Millais' famous painting of Ophelia, for which Siddal, representing the doomed girl, was immersed in a tub of water. Was it Buchanan's intention to imply that Rossetti was the means by which Siddal was subsumed and destroyed? That he was responsible for the death of his wife?

If so, he struck home. Rossetti was mortified by the pointed criticism and by the calling forth of the guilt that had been gnawing at him. He had not only desecrated his poor wife's body for the sake of ambition, but now, it seemed, it had been all for no good reason. Rossetti retreated to his house at Cheyne Walk. He lived among his private zoo of "uncouth animals"—owls, hedgehogs, wombats, dormice, armadilloes, marmots, squirrels, peacocks, kangaroos, parrots, jackdaws, and lizards; there was even, it was said, a zebu. His drug abuse continued, and he passed his days in a daze of chloral and whiskey, a virtual recluse.

Still, from the time of Siddal's death, Rossetti had been drawing closer and closer to the Morris circle, particularly to Jane Morris. Jane had become his new muse; he captured her in numerous pencil sketches, photographs, and paintings. She was his Guinevere, his *Astarte Syraica* (1875); his *Pandora* and his *Proserpine* (1877); his Desdemona. Although he continued to take up with Fanny Cornforth until the time of his death, it was clear that Jane had gained a place in Rossetti's heart next to that of Siddal.

The closeness of Jane Morris to Rossetti, and Burne-Jones to his dalliances, perhaps led the lonely Morris and Georgiana Burne-Jones to form—in their mutual unhappiness—an intimate friendship. Morris expressed his feelings for Georgiana in verse, and decorated manuscripts for her, with her initials emblazoned in his typical style.

In 1869 Millais exhibited The *Gambler's Wife*, which was praised for its excellent painting by his fellow artist Frederick Leighton. *The Widow's Mite* (1870) had been similarly praised, but also judged to be lacking in "old drama." In the Exhibition of 1868, he had seen his picture *Rosalind and Celia* derided by Swinburne, who claimed Millais' Rosalind was "a fair-faced bal-

let-girl, with a soul absorbed by the calf of her leg." Additionally, it was damned with faint praise by William Michael, who stated, "With all the signal merits of execution, the texture is not free from woolliness." If their disparagement fazed Millais, it is not noted. His paintings were ever increasing in popularity with the public. In 1874, he painted *The North-West Passage*, employing Edward Trelawney, an old comrade of poets Byron and Shelley, as a model.

Through the ensuing years, Millais would go on to paint a succession of portraits of saccharine young girls, including *Cherry Ripe* (1879), *Sweet Eyes* (1881), *Pomona* (1882), and *Lilacs*

Cherry Ripe
Sir John Everett Millais, 1879; oil on canvas; 34 x 25 3/4 in. (86.3 x 65.4 cm). Private collection. Adorable young girls became Millais' stock-in-trade in his later years. Here, Pre-Raphaelite realism has been forsaken for loose, impressionistic brushwork.

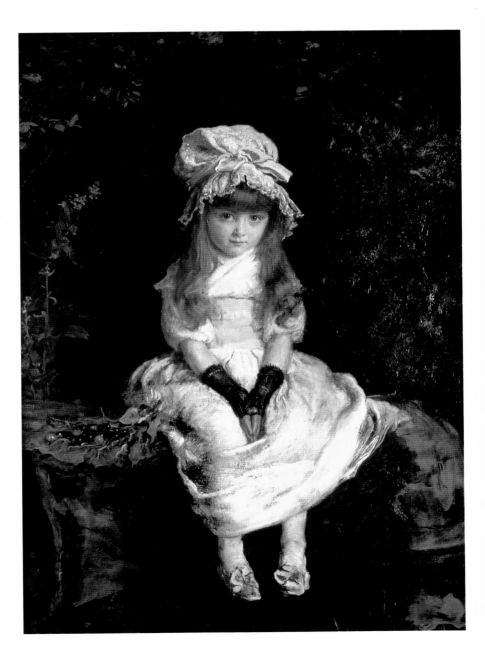

The North-West Passage

Sir John Everett Millais,
1874; oil on canvas;
69 1/2 x 87 1/2 in.
(176.5 x 222.2 cm).
The Tate Gallery, London.
Paintings such as these
displayed Millais' enor-
mous expertise. The
model for the old
captain was Edward
Trelawney, a compan-
ion of Byron's who
was considered a
delightful raconteur.

Nocturne in Black and Gold, the Falling Rocket

James Abbott McNeill Whistler, c. 1877; oil on canvas; ; 23 5/8 x 18 1/2 in.
(58.6 x 45.9 cm). The Detroit Institute of Art, Detroit, Michigan.
Here is the painting that caused Ruskin's downfall! When Whistler
took Ruskin to court for a scathing review he won damages—but only
a farthing. It was Ruskin's reputation that suffered the most damage.

(1886). He would never lack for praise throughout his career—except, perhaps, from his old friends.

An exception to this was, surprisingly, Rossetti. A visitor to Rossetti's home in 1871 wished to engage him in a discussion about Millais' increasingly bourgeois style. Rossetti was said to have quietly replied, "Why do you speak in that way of my old friend's work? It is not his fault that this age is a materialistic one. He finds it as God has permitted it to be, and it is my friend's choice to paint it as it now is."

Like Millais, Burne-Jones had always been a painter who almost from the beginning had been popular with the public. Unlike Millais, who apart from his genius was a conventional fellow— indeed, had become by now the mirror of the materialistic age— Burne-Jones was noted for his understated eccentricity. The scenes he portrayed were invariably the haunts of his own otherworldly imagination; they had been placed there by Chaucer, Malory, and Tennyson. As he aged Burne-Jones retired ever more into his beloved classical and medieval visions.

Some years, however, had more incident that others. In 1877, Burne-Jones gave one of his rare public exhibitions (he usually sold his work directly to his patrons or undertook commissions) and attracted the notice of a young American writer, Henry James. Unfortunately, Burne-Jones was also compelled to take the stand on behalf of his old friend John Ruskin, who was being charged with libel by another American, painter James McNeill Whistler. Ruskin, who had been elected Slade Professor of Art at Oxford in 1869, had continued to express his singular opinions, which, apparently, were becoming less relevant with time. He had accused Whistler of throwing a pot of paint at a canvas and charging for it; and in return, Whistler brought suit. The carnival atmosphere of the trial, in which Whistler won but was awarded a farthing's damages, brought no distinction upon its participants. The outcome seemed to imply that the great Ruskin had finally reached the end of his influence.

Morris, however, is another story. This highly imaginative artist was constantly evolving, in literature, art and design, and politics, until the day he died. It was in crafts, however, that he would make his greatest mark, for it was partly through his invention of a strikingly original system of ornament that the *fin de siècle* movement Art Nouveau would evolve.

A Medieval King

William Butler Yeats was a young man when he met the redoubtable Morris, who was then at the height of his fame. The poet said of the painter, "The dream world of Morris was as much the antithesis of daily life as with other men of genius, but he was never conscious of the antithesis and so knew nothing of intellectual suffering."

Such lack of self-consciousness could be extremely painful for the people around him. In 1875, the same year that Burne-Jones received an important commission for a series of paintings from the Conservative statesman Arthur Balfour, Morris, Marshall, Faulkner & Co. was erupting in acrimony. Morris had begun to dissolve the company in 1874. The principals were complaining, loudly, of nonpayment; and Rossetti went so far as to write a scathing satire of the dissolution, calling it *The Death of Topsy*.

Morris reopened his enterprise under the name Morris & Company. In the following decades, the company would become famous for its textiles and wallpapers, whose designs from nature had been painstakingly worked out by Morris. Reproductions of these designs remain popular to this day.

As he had done since the Red House, Morris sought to impose his will upon all his surroundings, so that, recounting how his elder sister had worked embroidery for Morris' daughter, May, [Yeats reported]:

> The hangings round Morris's big bed at Kelmscott House, Oxfordshire, with their verses about lying happily in bed when "all birds sing in the town of the tree" were from her needle though not from her design. She worked for the first few months at Kelmscott House, Hammersmith, and in my imagination I cannot always separate what I heard and saw from her report, or indeed from the report of that tribe or guild who looked up to Morris as to some worshipped mediaeval king.

One of the many glories to come out of Morris & Co. was the tapestry, *The Adoration of the Magi* (1890), which was designed with the assistance of Morris' old friend Burne-Jones.

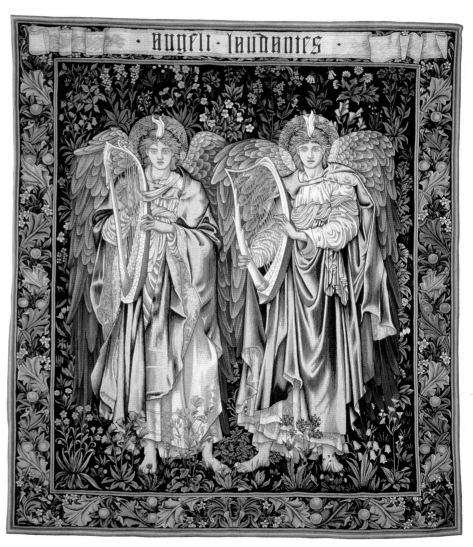

Over this time, Morris had been giving lectures in Fabian Socialism. He offered discussion groups at his house, which were attended by himself, George Bernard Shaw, the young Yeats, and local men from the factories. He gave lectures and had pamphlets printed detailing the advantages of socialism. Politics perhaps inspired him to *The Dream of John Ball* (1888), a prose romance about the fourteenth-century revolt of Wat Tyler.

In 1891, he began the influential venture the Kelmscott Press, where he created the still celebrated Kelmscott Chaucer (1896).

The Death of the Brotherhood

Rossetti died at Birchington-on-Sea on April 9, 1882, where he was being treated for chloral

Angeli Laudantes

Morris & Co. (William Morris), 1894; tapestry, silk and wool. Victoria & Albert Museum, London. Morris tapestries were among the most sought-after. The workmanship was superb, and the designs often originated with Rossetti, Burne-Jones, and others.

addiction. Among the pictures he left behind was *Found*, begun in 1851 and unfinished at his death. As usual, the costume is medieval: a country lad arrives in London and finds that his old love is now a streetwalker, plying her trade in the lowest of neighborhoods. The woman recoils from her former lover, collapsing and turning her head in shame.

Perhaps the artist could not finish this picture because he did not truly believe in it. It could have been that his early contempt for women (particularly models) prevented him from believing in a "conscience," as delineated by Holman Hunt; and even if he had, it could have been also that his experience with Siddal prevented him—in the end—from taking so superficial a view.

Rossetti's younger sister, Christina, in spite of being a lifelong invalid, would outlive him by twelve years. Her reputation was secure with *Goblin Market*, the most curious and "fleshly" of her works. Today, it is considered a fascinating example of Victorian sexual repression, and for this reason has been ceaselessly mulled over by scholars and vulgarians alike. Toward the end of her life, Christina Rossetti worked on a collection of poems entitled *Out of the Deep Have I Called Unto Thee, O Lord*, in which the following is the last work:

LIGHT OF LIGHT

O Christ our light, Whom even in darkness we
(So we look up) discern and gaze upon,
O Christ, Thou loveliest Light that ever shone,
Thou Light of Light, Fount of all lights that be,
Grant us clear vision of Thy Light to see,
Tho' other lights elude us, or be gone
Into the secret of oblivion,
Or gleam in places higher than man's degree.
Who looks on Thee looks full on his desire,
Who looks on Thee looks full on Very Love:
Looking, he answers well, 'What Lack I yet?'
His heat and cold wait not on earthly fire,
His wealth is not of earth to lose or get;
Earth reels, but he has stored his store above.

Swinburne, a so-called fleshly poet himself who had enjoyed the austere measures of Christina, was invalided about this time as well from excess and epilepsy. He had retired after 1879 to the home of his friend, the solicitor

Hylas and the Water Nymphs

John William Waterhouse, 1896; oil on canvas; 38 7/8 x 64 1/4 in. (98.2 x 163.3 cm). Manchester City Art Gallery, Manchester. While polite society eschewed direct references to sexuality, fair license was given to the undraped female figure in classical subjects, making them desirable to both artists and collectors in the Victorian period.

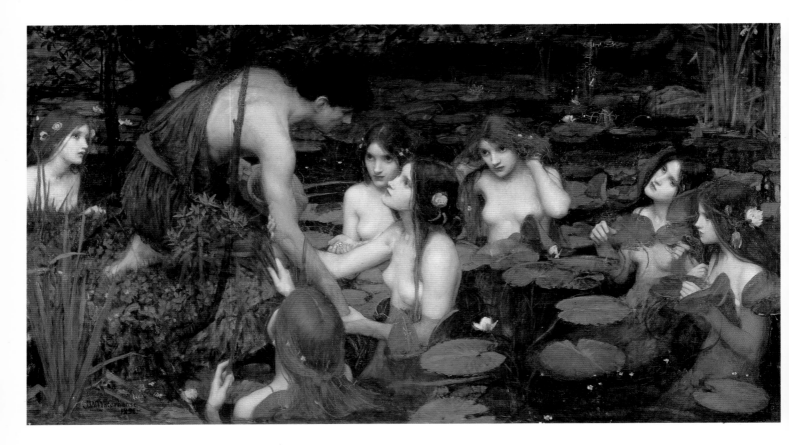

Theodore Watts-Dunton, who looked after him. Under a strict regimen, he continued to write poetry and criticism until his death in 1909.

"So Now the Whole Round Table is Dissolved"

Millais became president briefly of the Royal Academy before his death in 1896. Both he and Burne-Jones had attained baronetcies. Burne-Jones had even been given an honorary degree from Oxford in 1881, and was made an Associate of the Academy in 1893. Morris disdained such elitism, as did Holman Hunt, whose highest reward was an Order of Merit.

Now into its fifth decade, Pre-Raphaelite influence was still apparent in the paintings of John William Waterhouse, whose *Hylas and the Water Nymphs* (1897) and *Lady of Shalott* (1888) brought to mind the early paintings of the Brothers. Holman Hunt himself was working on his own *Lady of Shalott*, begun in 1886 and completed in 1905.

Ruskin died in 1900 of influenza. During the course of his long and storied life, he had given £157,000 to art and other public works. His name, though still widely respected, had been tarnished by the Whistler episode. His work remains today as a standard by which all art criticism must be measured.

Slowly, yet assuredly, came the renunciation of Pre-Raphaelite ideals, once revolutionary, now old-fashioned. According to Yeats:

> I had seen the change coming bit by bit and its defense elaborated by young men fresh from the Paris art-schools. "We must paint what is in front of us," or "A man must be of his own time," they would say, and if I spoke of Blake or Rossetti they would point out his bad drawing and tell me to admire Carolus Duran and Bastien-LePage. Then, too, they were very ignorant men; they read nothing, for nothing mattered but "Knowing how to paint," being in reaction against a generation that seemed to have wasted its time upon so many things.

Yeats' complaint that literature and art were now severed was not, however, strictly true. In his native Dublin, there had emerged a new literary lion, whose work would inspire a new young artist. The writings of Oscar Wilde and

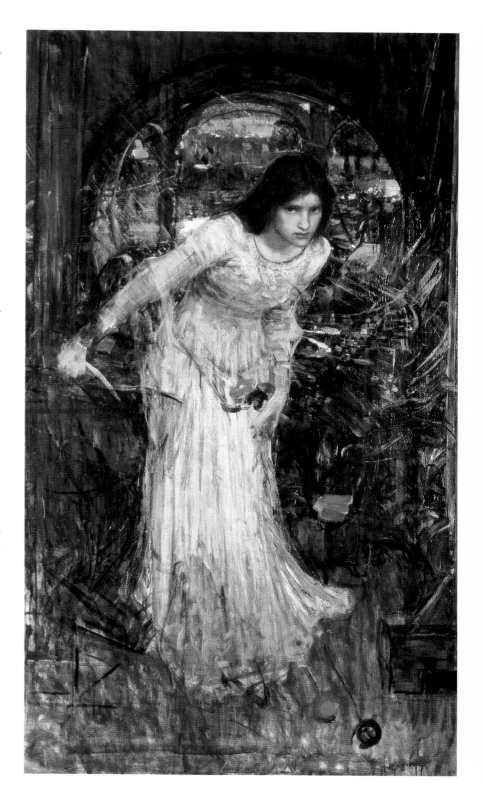

The Lady of Shalott

John William Waterhouse, 1894; oil on canvas;
47 1/2 x 27 in. (120.5 x 68.3 cm). Falmouth Art Gallery, Cornwall.
Works such as this occasionally captured some of the genuine distress of their models, whose mostly modest backgrounds ill-prepared them for the world their beauty granted them.

the drawings of Aubrey Beardsley to this day are so closely associated as to be sometimes inseparable. Most famous are Beardsley's illustrations for the publication of Wilde's Symbolist play, *Salome* (1894). In the same year, Beardsley undertook the illustration for a yet another edition of that Pre-Raphaelite bible, Malory's *Morte d'Arthur*. Beardsley's interwoven flower designs, in their incipient Art-Nouveau style, owe much to Morris' designs.

William Holman Hunt, the last surviving painter of the original Pre-Raphaelite Brotherhood, died in 1915. In 1905 he published The *Pre-Raphaelite Brotherhood*, which included his memoirs and his theory of painting, and he was able to provide there many of the last words on the subject.

Of the Brothers, Hunt was said to have remained the most faithful to the ideal. Doing so had brought himself fame and fortune, but this did not come easily. As he stated, rather wistfully, in his memoirs, "I was never successful in working for medals, many dunces made more presentable drawings than mine; but except that I should have been glad to cheer up my parents, I fretted little at my failures at competition."

In the end, he must have known that in spite of the vicissitudes of artistic fashion he and the Brotherhood had triumphed. Thanks to their efforts and dedication, the world of their art had helped shake off the pervasive gloom of the Victorian age, and had greeted a new day with uncommonly fresh eyes.

Cover of
Le Morte d'Arthur
Aubrey Beardsley, 1894;
book binding. Private collection.
Beardsley's design, even
while undergoing its sea
change into Art Nouveau,
clearly shows the imprint
of Morris' influence on design
and the art of the book.

The Lady of Shalott
William Holman Hunt, 1897; oil
on panel; 17 1/2 x 13 5/8 in.
(44.4 x 34.6 cm). Manchester
City Art Gallery, Manchester.
This painting was undertaken
by Holman Hunt in his last
years, when his determinedly
Pre-Raphaelite style was
said to have suffered from
being over-labored. Holman
Hunt had the last word
over his Brothers by writing
the history of the movement.

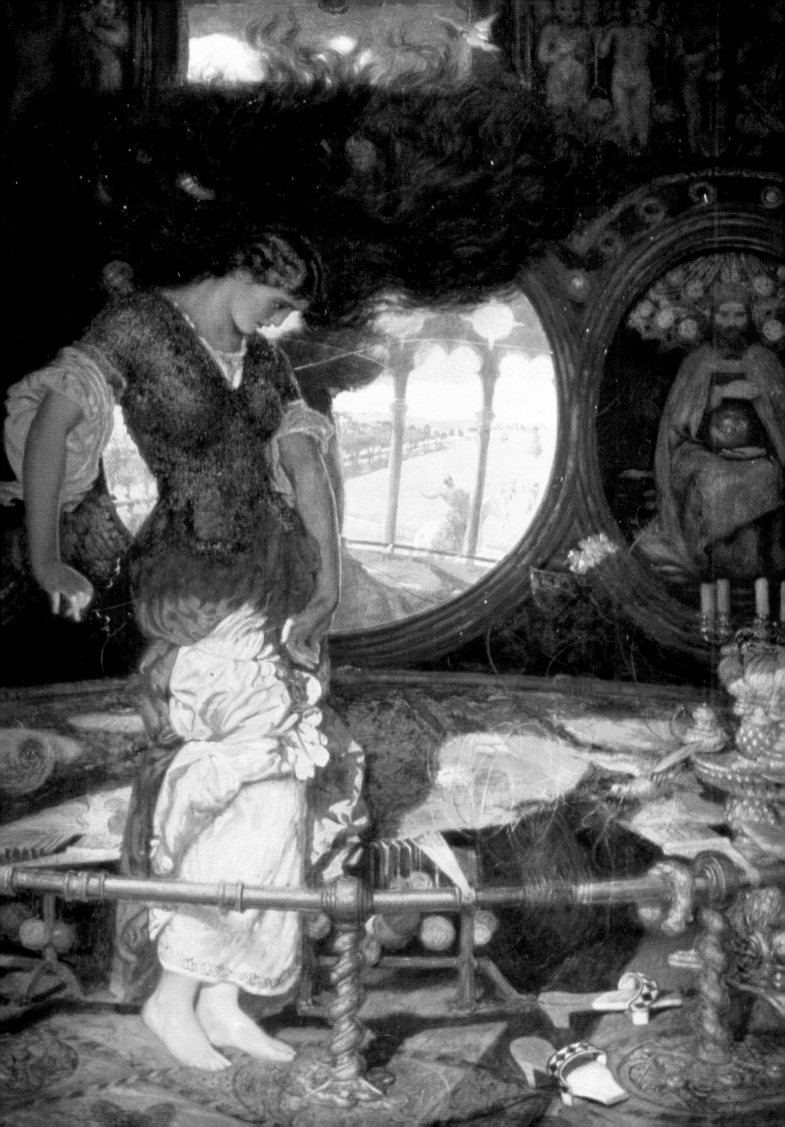

The Briar Rose Series: The Prince Enters the Briar Wood
Sir Edward Coley Burne-Jones, 1871–90; oil on canvas; 122 x 139 in.
(309.5 x 353 cm). Faringdon Collection, Buscot Park, Faringdon.
An earlier study for this remarkable and eerie panel, entitled
The Sleeping Knights, was done by Burne-Jones about 1870.

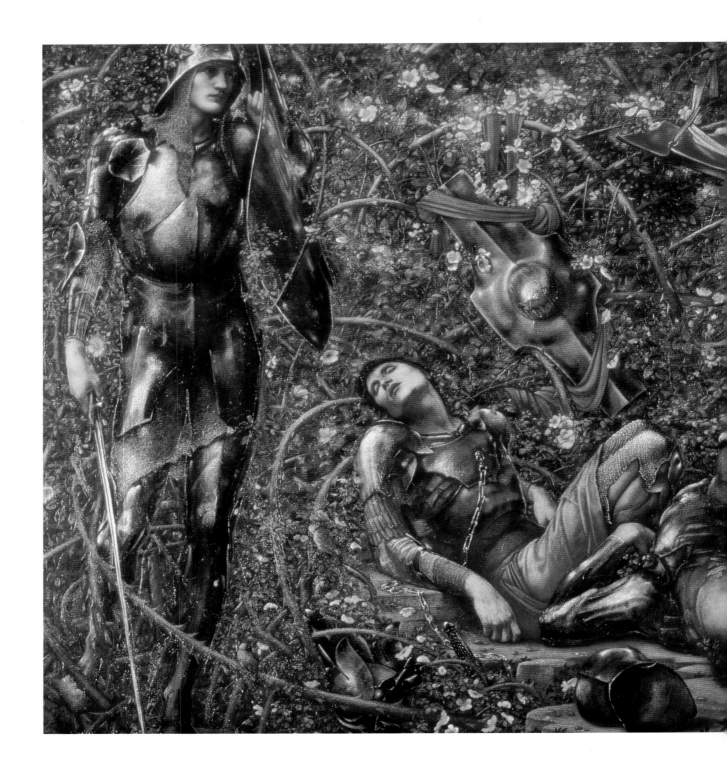

The Garden of the Hesperides

Sir Edward Coley Burne-Jones, 1869–72; oil on canvas;
47 x 38 1/2 in. (119.3 x 97.8 cm). Private collection.
This lovely painting draws inspiration from the early Italian masters, notably Botticelli.
It was Rossetti who encouraged the young Burne-Jones to visit Italy to view the
distant paintings which were only available to him in Britain in the form of engravings.

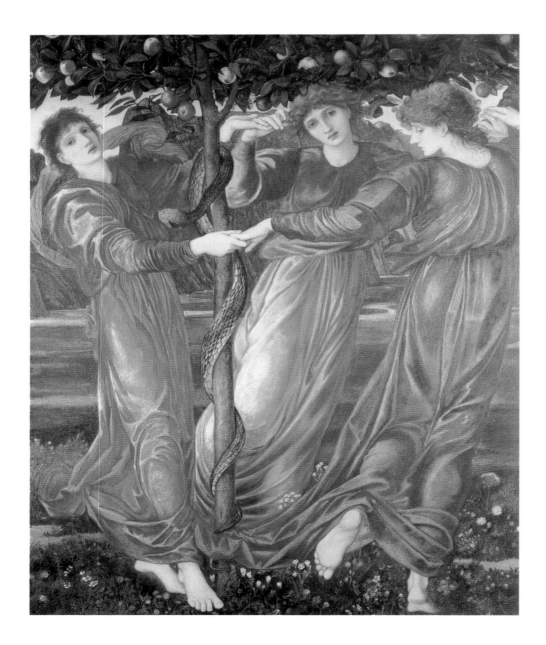

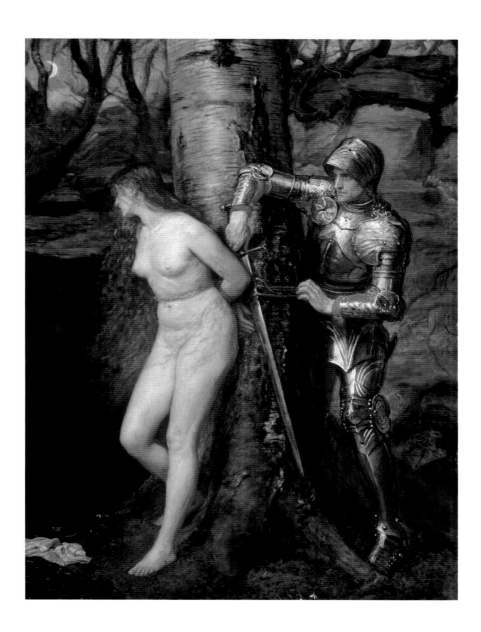

The Knight Errant

Sir John Everett Millais, 1870; oil on canvas. The Tate Gallery, London.
This ambiguous painting stands out from Millais' sunny ladies
and children of the period, causing the viewer to wonder
whether the damsel has been rescued or menaced by the knight.

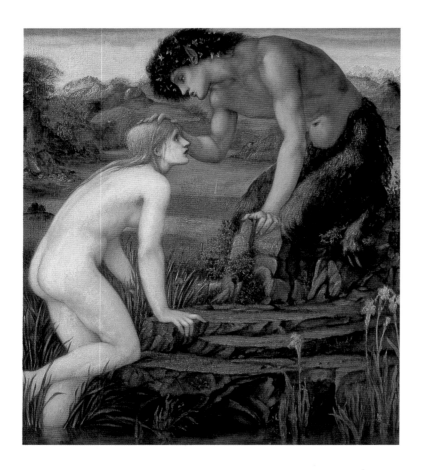

Pan and Psyche

Sir Edward Coley Burne-Jones, 1872–74; oil on canvas;
25 3/4 x 21 5/8 in. (65.4 x 55 cm). Agnew & Sons, London.
This remarkable painting contrasts a pale beauty with
a bestial half-man. The subject is taken from mythology,
but appears to have a disturbing hidden message.

Haydee Discovers the Body of Don Juan

Ford Madox Brown, 1870–1873; oil on canvas;
45 x 55 1/4 in. (115 x 142 cm). Musée d'Orsay, Paris.

Rossetti became aware of Madox Brown through an exhibition of his
sketches shown at Westminster Hall in 1844. Later, as Rossetti waited to
enter the Academy, he met Madox Brown and asked to become his pupil.

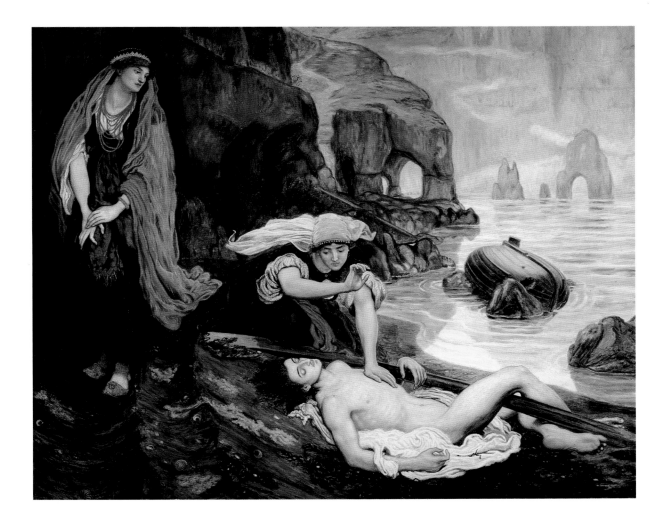

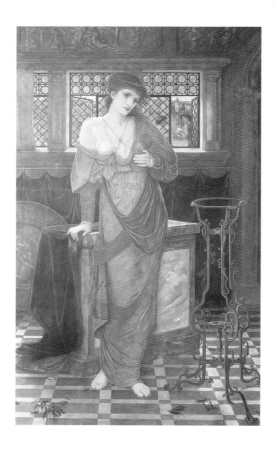

Isabella and the Pot of Basil

John Malhuish Strudwick, 1879;
tempera and gold paint on canvas; 39 x 23 in.
(99 x 58.5 cm).De Morgan Foundation, London.
Once again, Keats' Isabella is the
subject of this Pre-Raphaelite-style
picture. The media employed were used
extensively throughout the middle ages.

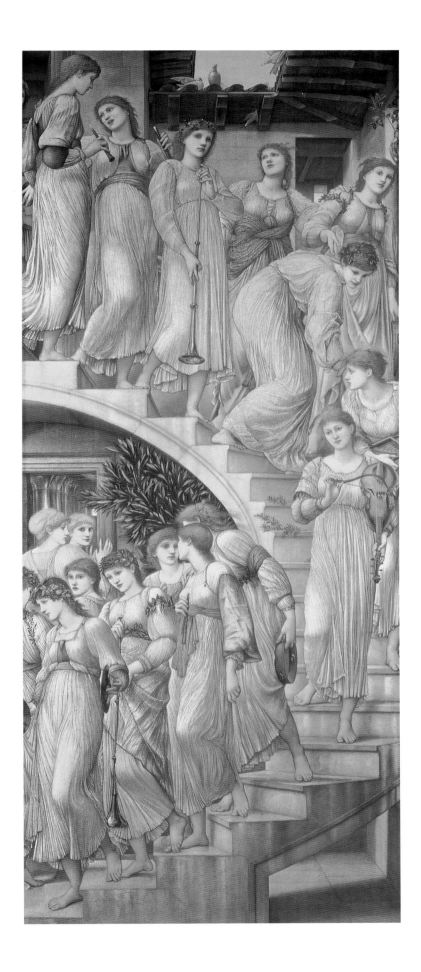

The Golden Stairs
Sir Edward Coley Burne-Jones, 1880; oil on canvas; 109 x 46 in. (276.9 x 116.9 cm). The Tate Gallery, London.
In this breathtaking picture of idealized beauty, a line of scantily clad women descend a staircase. The size of the work makes the subject matter even more impressive.

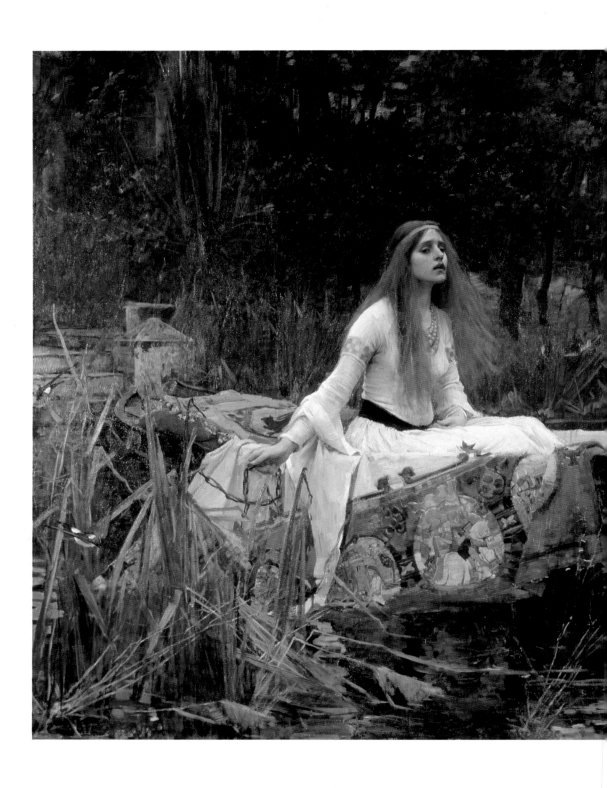

The Lady of Shalott
John William Waterhouse,
1888; oil on canvas;
64 1/4 x 78 3/4 in.
(163.1 x 200 cm).
The Tate Gallery, London.
Like Ophelia, the
distressed Lady of Shalott
was a popular Romantic
subject. Here, Waterhouse
has shown his model still
coursing toward Tennyson's
"many towered Camelot."

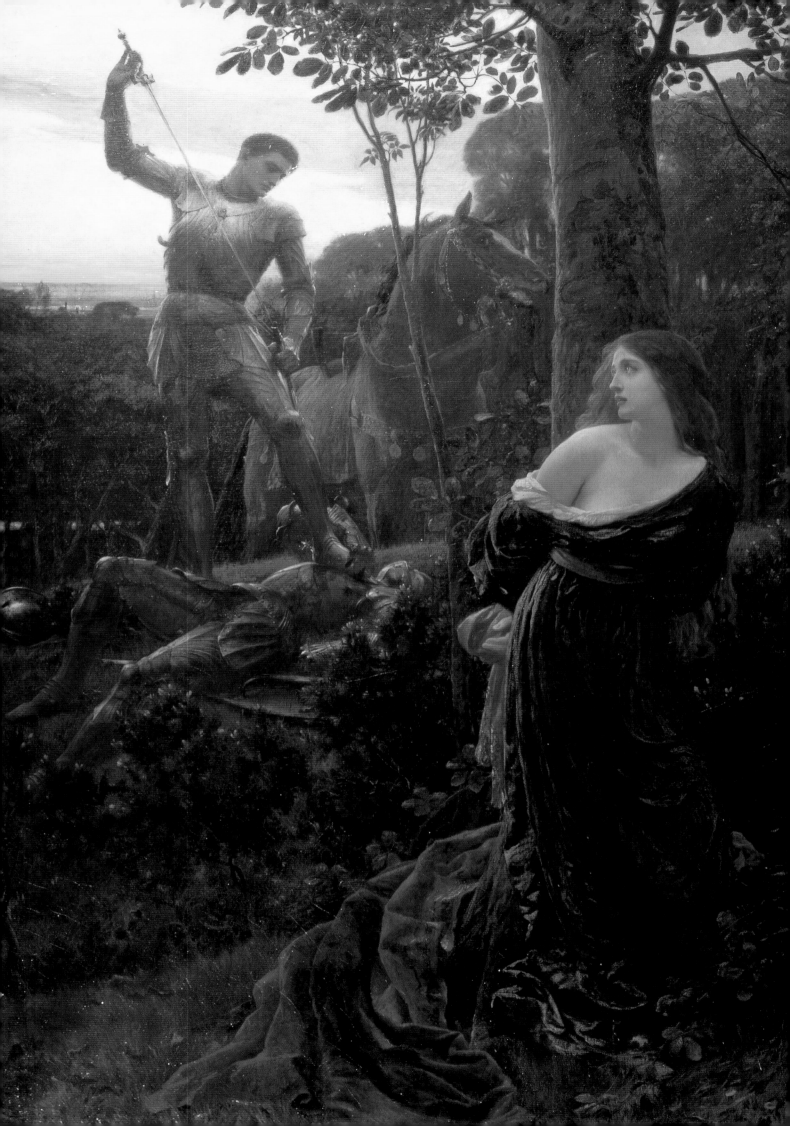

King Cophetua and the Beggar Maid

Sir Edward Coley Burne-Jones, 1884; oil on canvas; 115 1/2 x 53 1/2 in. (293.4 x 135.9 cm). The Tate Gallery, London. One of Burne-Jones most famous paintings, the subject is taken from a legend popularized by Tennyson. The poor girl plucked by fate into wealth has always been a popular theme.

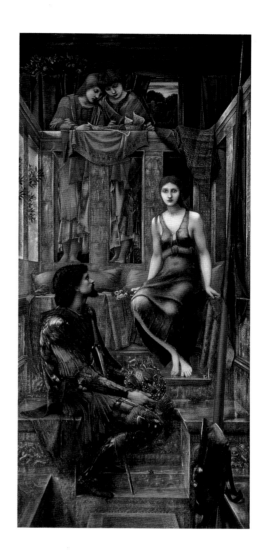

Chivalry

Frank Dicksee, 1885; oil on canvas; 72 x 53 1/2 in. (183 x 135.9 cm). The Forbes Magazine Collection, New York. Dicksee's painting has been compared to the earlier damsel-knight scenario as portrayed by Millais. Although considerably more decorous, it has the same disturbing atmosphere.

The Magic Circle

Sir Edward Coley Burne-Jones,
1880; watercolor. The Tate Gallery, London.
A mysterious necromancer and his
audience form the subject matter of this
Burne-Jones painting. The master-pupil
relationship continued to fascinate the artist.

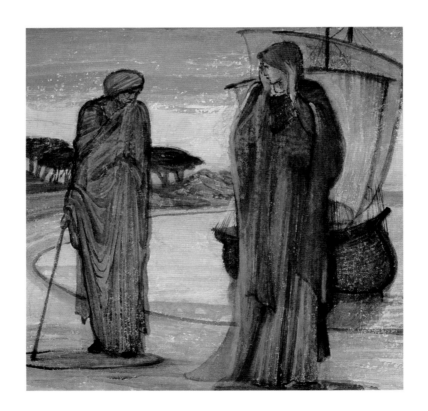

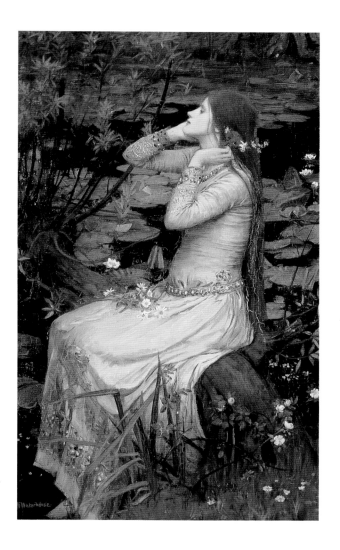

Ophelia

John William Waterhouse, 1910; oil on canvas;
40 x 24 in. (102 x 61 cm). Christie's, London.
Waterhouse's Ophelia is as disheveled as Millais',
but here, she is depicted before her untimely death.

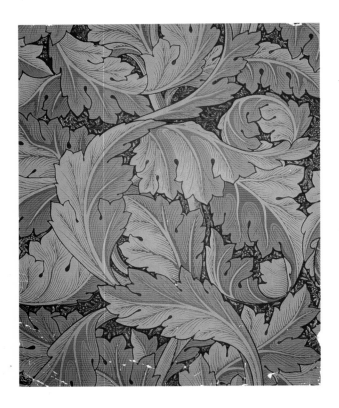

Acanthus Wallpaper

William Morris, 1891; print.

Victoria & Albert Museum, London.

Morris developed a unique system of
ornamentation, one that paved the way
for many others, for in this design can be
seen the roots of Art Nouveau, and even Art Deco.

Boer War, 1900

John Byam Liston, 1900; oil on canvas;
39 3/8 x 29 1/2 in. (100 x 75 cm).
Birmingham City Museums, Birmingham.
Here, Victorian emotional restraint is
found in a quiet country scene. The influ-
ence of the Pre-Raphaelites is shown in
the true rendering of the natural surroundings.

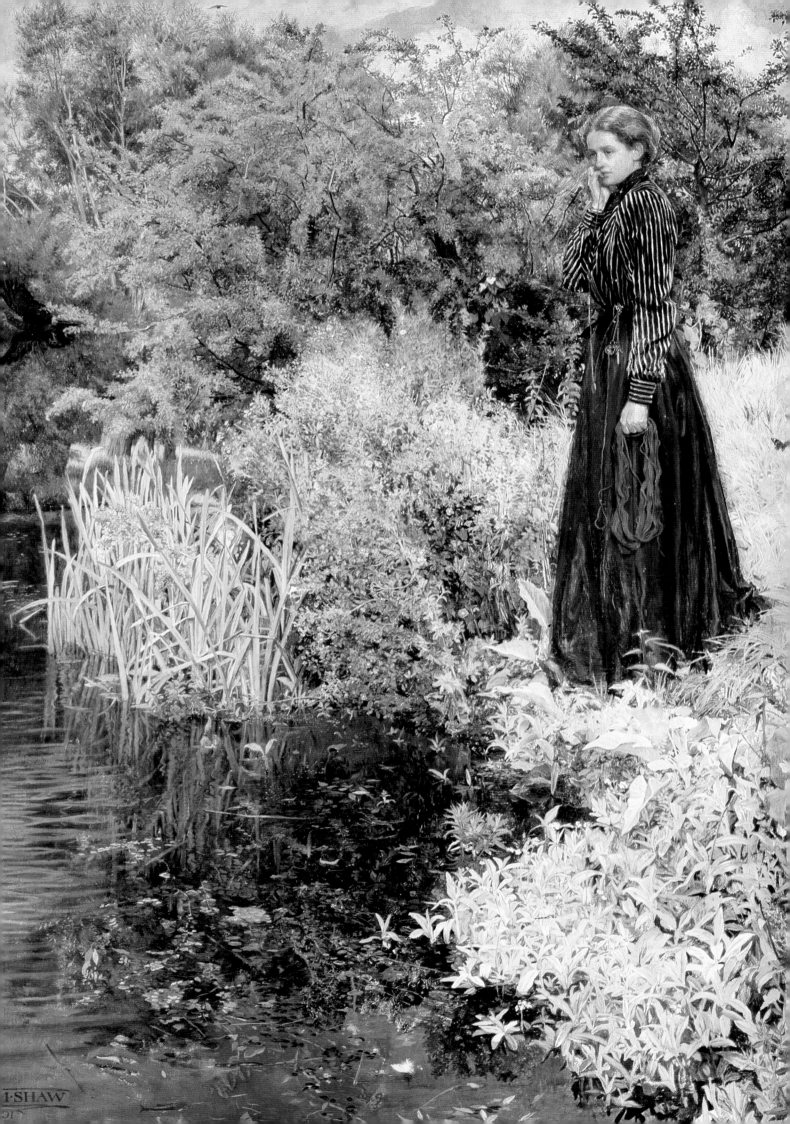

INDEX

Page numbers in **bold-face** type indicate photo captions.